IMAGES
of America

REFORM JEWS
OF MINNEAPOLIS

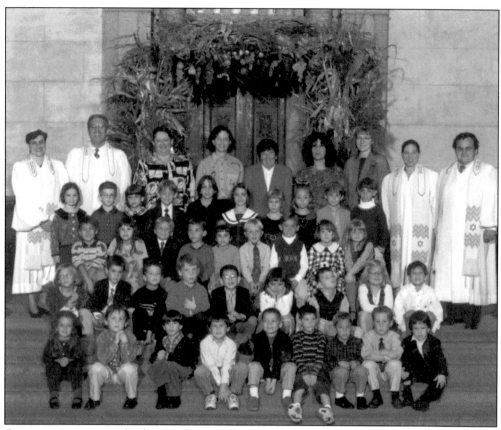

Consecration services for five- and six-year-old children are an annual event during Temple Israel's celebration of Sukkot. Children are called to the pulpit one by one to be blessed, and each one is given a tiny Torah as an introduction to the Sunday School classes they will begin a year or two later. The class of 1998 posed for their photo with, from left to right, Assistant Rabbi Andrea London and Senior Rabbi Joseph Edelheit, nursery and religious school teachers Judy Rotenberg, Sheryl Moser, Sarene Silver, Tamar Ostfield and Jayne White, Assistant Rabbi Marcia Zimmerman, and Cantor Barry Abelson. (Courtesy of Temple Israel.)

About the Cover: Council Camp and Camp Chicamaga were both programmed to give children "two-week vacations in a wholesome Jewish atmosphere" by founder and camp director Leonard Neiman. Sponsored by the Minneapolis chapter of the National Council of Jewish Women, Council Camp opened on the St. Croix River in 1938. More than 400 children attended camp the first year, and enrollment continued to grow. In 1946, it became an independent operation and moved to Aitkin, MN. Pictured from left to right are counselors Betty Mann, Rita Marker Litin, Lois Klugman Goldberg, Lillian Falk Goldfine, Roz Nathanson Schwartzman, Esther Hakim Rosen, Rita Beugen Mazie, Lynn Weil Nathanson holding Billy Neiman in her lap, Billy's father, Leonard Neiman, Louise Lasker, waterfront director Mickey Nathanson, and Joan Gordon Binder. Other counselors included Marvin Kahner, Audrey Zack Rees, Jim Dobrin, Lois Bix Kozberg, Marilyn Weiskopf Tritter, and Betty Braufman. (Courtesy of Tom Lewin.)

IMAGES
of America

REFORM JEWS
OF MINNEAPOLIS

Rhoda Lewin

ARCADIA
PUBLISHING

Published by Arcadia Publishing
Charleston, South Carolina

Printed in the United States of America

Library of Congress Catalog Card Number: 2004108895

For all general information contact Arcadia Publishing at:
Telephone 843-853-2070
Fax 843-853-0044
E-mail sales@arcadiapublishing.com
For customer service and orders:
Toll-Free 1-888-313-2665

Visit us on the Internet at www.arcadiapublishing.com

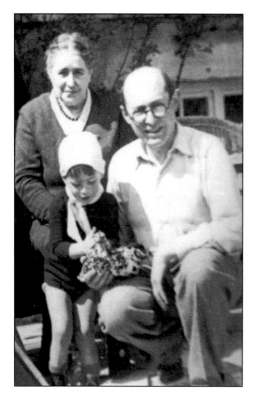

This book is dedicated to my husband, Tom Lewin, who helped me with my research and scanned so many photographs for this book. He was born in Berlin in 1931, and still recalls how sad he was when his playmates were joining the Hitler Youth, but he could not join because he was a Jew. He escaped to England in 1939, and when World War II ended he traveled by ship to New York and then by train to Minneapolis, where he was reunited with his father, Egon Lewin, who had escaped from Germany in 1940. My book is also dedicated to my husband's grandmother, Recha Lewin, who died in 1943 in a cattle car en route to a Nazi death camp. Pictured from left to right are Recha, Tom, and Egon Lewin in Berlin, c. 1933.

CONTENTS

ACKNOWLEDGMENTS

Words cannot express my gratitude to my husband, Tom Lewin, who helped in my research, spent so many hours scanning every photo and document in this book, and also shared photos he had taken as a young man involved in community events and outdoor activities. Many other people also deserve a special "thank you." My son, Jeffrey Lewin, printed out the computerized disk photos from Shir Tikvah. Rosalie Kiperstin, publisher of *Minnesota Jewish Life*, and her husband, Frank Kiperstin, gave me permission to use photos from her magazine.

Marvin Kahner identified many people in the cover photo. Temple Israel staff members Neal Frank, Georgia Kalman and Charlotte Moses, and tireless volunteer Alta Harris, provided many photographs, many of them from the permanent Archives Exhibit installed outside Minda Hall in 1998—a project I co-chaired with Marjorie Mandel and Roland Minda. The histories of Bet Shalom and Shir Tikvah were provided by Rabbi Norman Cohen, Andrea Hartsman Blumberg, Evelyn Shapiro, Rabbi Stacy Offner, and Jason Herrboldt. Many thanks also go to Bob Beugen, Bob Lazear, David Harris, and Jennifer Lewin, who helped identify people in many of the photographs, and to those who shared their memories and their photographs, including Florence Schoff, Jean Ellis Minter, Bette Globus-Goodman, Meredith Montgomery, Keith Prussing, Anita Schwartz, Sam Stern, and Mordecai Specktor, editor of *American Jewish World*. Two published works that also provide priceless details of our community's early years are Rhoda G. Lewin's "Temple Israel: A Brief History 1878-1987" and Ruby Danenbaum's "A History of the Jews of Minneapolis," which was published in *The Reform Advocate* in Chicago, IL. on November 16, 1907.

INTRODUCTION

German Jews began emigrating to the United States in the 1850s. Most of them stayed in New York or in other cities on the East Coast, but some traveled by train to Minneapolis, because they'd seen the advertising brochures Minnesota was sending to Europe encouraging immigrants to come to the "Empire State of the new North-West," where they would find a "booming economy," or because they'd seen sacks of flour from Pillsbury Mills in Minneapolis, and there must be jobs, and a healthy economy, in a city whose products found their way to Berlin, Frankfurt, Stuttgart, and other European cities.

Minneapolis was incorporated as a city in 1856, and although the population was only 13,000 in 1870, it tripled to almost 40,000 during the next five years. Flour mills and lumber mills were the fastest-growing industries, and their employees and their families shopped at the German entrepreneurs' clothing and furniture stores and other businesses, most of them on Washington Avenue, the eastern edge of what is now downtown Minneapolis.

There were now 172 Jews living in Minneapolis, almost all of them German newcomers who had a close sense of community, and in 1878 they founded the city's first Jewish congregation, Shaarai Tov, which is now known as Temple Israel. They also began publishing a weekly newspaper called the *American Jewish World*, which today is one of the very few Jewish community newspapers in the United States that is still independently owned; most are written, edited, and published by Jewish community organizations.

Today, Minneapolis has three Reform Jewish congregations, Temple Israel, Bet Shalom, and Shir Tikvah, with a combined membership of more than 3,000 families. Bet Shalom was founded in 1981 and Shir Tikvah in 1988, but Temple Israel celebrated its 125th anniversary in 2003 and is one of the ten largest Reform congregations in the United States, with a membership of almost 2,000 family units. It is also the first congregation in that category to have a woman as its senior rabbi, and it has always been well-known in, and closely related to, the non-Jewish community, because its rabbis and its members have assumed a leadership role in pioneering projects like Jewish-Catholic relations, interfaith dialogue and education, and NIP, the Neighborhood Involvement Project, where members of Temple Israel and four neighboring churches provide employment counseling and training, free medical and dental care, food supplies, and many other services for those in need.

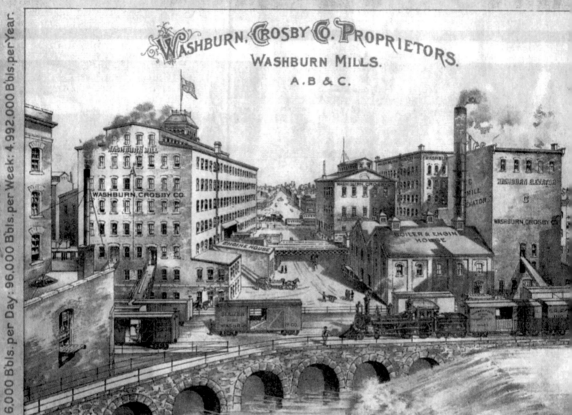

St. Anthony Falls, on the Mississippi River, powered the sawmills and flour mills that were the leading industries in Minneapolis by the late 1850s. By the 1880s flour milling was two-thirds of the city's manufacturing output, and during the industry's heyday between 1880 and 1930, the Washburn A Mill processed enough wheat to fill 175 railroad freight cars every working day—enough to bake more than 12 million loaves of bread! (Courtesy of Fred Foley's Copper Dome Pancake House & Family Restaurant, St. Paul, MN.)

One

Journey to the New World
Destination Minneapolis

In 1856 the Minnesota state legislature authorized a new "town" called Minneapolis. Hogs and chickens roamed the unpaved streets and it was against the law "to drive any horse, mule or other animal at a rate of speed exceeding eight miles per hour," but the city was already the headquarters for the state's rapidly growing flour-milling and lumber industries, and the German Jews who had begun coming to America in the 1850s had brought enough money with them to start small businesses. Minneapolis's first Jewish citizen was Samuel Louchheim, who sold clothing and other supplies to the lumbermen and factory workers, and when Ralph Rees, whose descendants still live in Minneapolis, arrived in 1869, he also opened a clothing store on Washington Avenue, in the city's first brick building.

Then, in 1870, a Chicago fire killed hundreds of people and many Chicago residents moved to Minneapolis, including Jacob Cohen, Jacob Scholl, A. Krutzkoff, Joseph Robitshek, Simon Gittleson and Cyrus Rothschild. On April 23, 1872 the *Minneapolis Morning Tribune* reported that the city's Jewish population "consists of nine heads of families plus several single men and women," and in 1873 Jacob and Marichen Deutsch arrived just before the birth of their son, Henry—the first Jewish boy born in Minneapolis. When Max Segelbaum arrived in 1874 he also opened a dry goods store on Washington Avenue, and later he and his brother Sander opened Segelbaum Department Store, the first business on Nicollet Avenue. By the mid-1870s there were 172 Jews in a population that had grown from 13,000 to almost 40,000 in less than five years, and then, between 1877 and 1900, the city's population more than quadrupled, to just over 200,000, and the Jewish population increased to 8,000, most of them East European Jews fleeing Russian pogroms. By now, though, many families whose descendants still live in Minneapolis— the Brins, Wolffs, Ehrlichs, Metzgers, Sulzbergers, Bernsteins, Werths, Wilkes, Mikolas, Jacobs, Weils, Weiskopfs, Kantrowitzes, and Rosenfields—owned some of the city's largest businesses, including jewelry stores (S. Jacobs & Co.), clothing manufacturers (Robitshek, Frank and Heller), wallpaper sales (Kayser & Co.), cigar manufacturing and sales (S. Pflaum & Sons), and Monasch Lithographing Co. Isaac Kaufman and Louis Conhaim were the city's leading life insurance salesmen; Emanuel Cohen served on the city's first Charter Commission; Louis Levy organized the State Labor Bureau; and Simon Meyers was elected to the State Legislature in 1898. By 1907 University of Minnesota faculty included Temple Israel Rabbi Samuel Deinard as professor in Semitic Languages; attorney Robert Kolliner taught in the Law School; and a pioneering woman, Lillian Cohen, taught Chemistry. Emanuel Cohen, Simon Meyers, Henry Deutsch, Samuel Levy, Jonas Weil and Frank Dittenhoefer were now practicing law, and doctors practicing medicine included Emil Robitshek, Harry Cohen, Samuel Rosen, and George Gordon, a professor at Hamline University's College of Physicians and Surgeons.

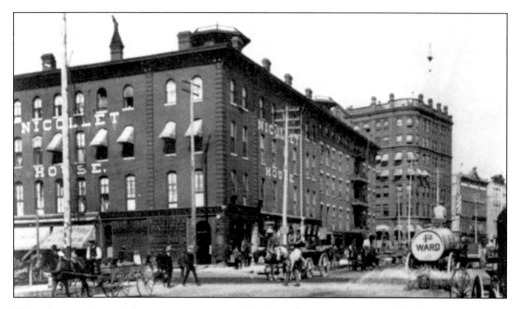

This photograph and the top one on page 11 show the intersection of Washington Avenue with Nicollet and Hennepin Avenues in the 1890s. Washington Avenue was Minneapolis's "main street," with apartment buildings and row houses, 7 banks, 29 clothing stores, 11 hotels, a music academy, and entertainment halls where touring companies from New York performed vaudeville, Shakespeare, and tearful melodramas. In 1870 the city's population was 13,000, but in ten years it had already grown to 40,000! (Courtesy of Temple Israel Archives and Minnesota Historical Society.)

This postcard shows the first buildings at the University of Minnesota, on what is now known as the East Bank campus. One hundred years later there are 50,000 students attending classes in 303 buildings on the historic East Bank, the West Bank campus across the Mississippi River,

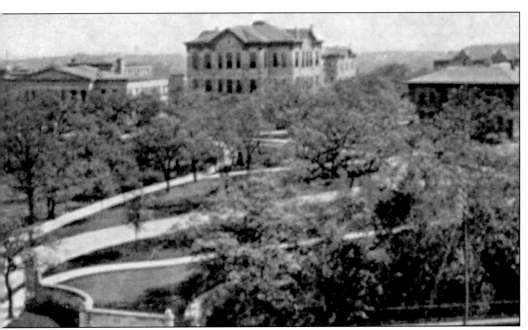

and the College of Agriculture in St. Paul—which some students jokingly refer to as "the farm campus" or "Moo U." (Courtesy of Jean Minter.)

WHAT ARE MISFITS?

They are Suits, Overcoats and Pants made by Merchant Tailors which are misfitted or uncalled for. We have agents who buy these garments at a great sacrifice.

Therefore we can sell them at One half the ordered price.

Suits and Overcoats made to order for $25 we sell for $10.

Suits and Overcoats made to order for $30 we sell for $12.50.

Suits and Overcoats made to order for $35 we sell for $15.

Suits and Overcoats made to order for $40 we sell for $18.

All goods sold by us kept pressed and repaired free of charge.

Dress suits to rent.

MISFIT CLOTHING PARLORS,
241 Nicollet Avenue.

Joseph Osterman owned this very successful men's store, which he called "Misfit Clothing Parlors," at 241 Nicollet Avenue in downtown Minneapolis. He took Saturday mornings off, though, to lead Torah reading at Shaarai Tov with his friend, Dr. Robitshek, and he was one of the first to buy an acre of farmland in the area which would one day become the suburb called St. Louis Park. (Courtesy of Jean Minter.)

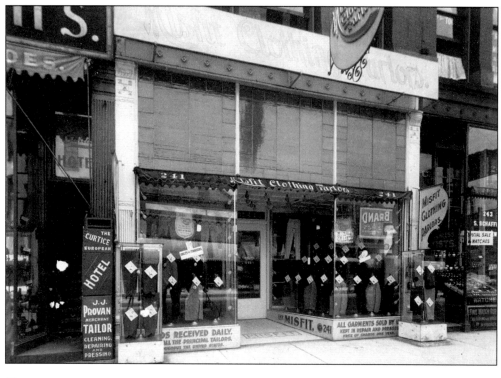

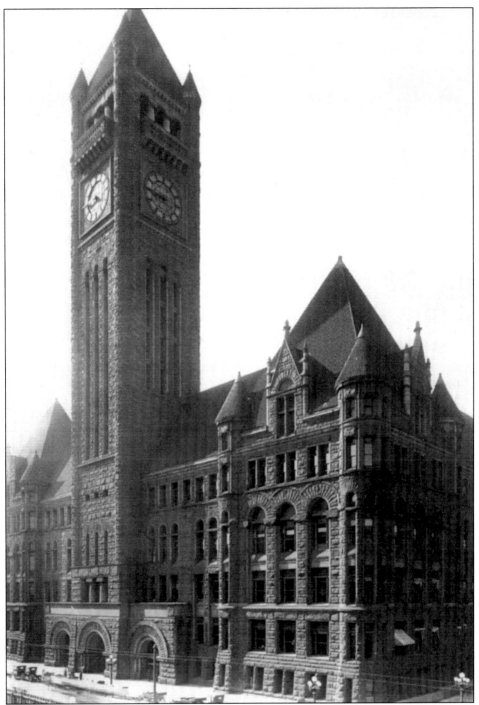

Minneapolis city offices moved into the new Municipal Building, now the City Hall and Courthouse, in mid-December, 1901. In an article published in *McClure's Magazine* in January, 1903, Lincoln Steffens called Minneapolis "the metropolis of the Northwest . . . a New England town on the upper Mississippi . . . a Yankee town with a small Puritan head, an open prairie heart, and a great, big Scandinavian body." (Courtesy of Minneapolis Public Library.)

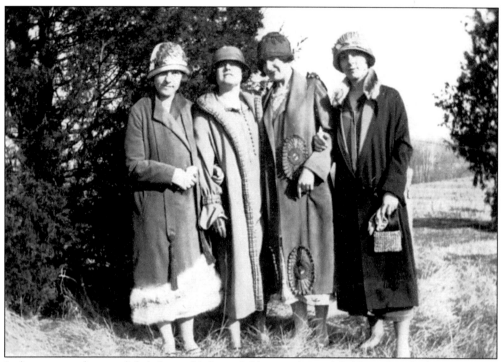

In later years, these stylish ladies told their children and grandchildren they had to wear hats because there weren't any beauty parlors yet, so they couldn't have their hair done! Pictured from left to right are Hattie Ellis, Helen Osterman, Tecla Ziskin, and Tessie Osterman. (Courtesy of Jean Minter.)

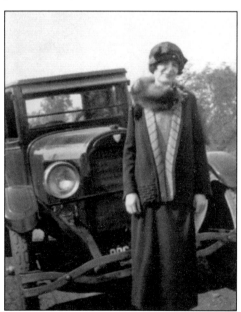

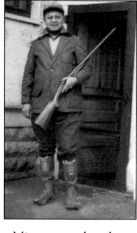

Benjamin (Ben) C. Schwartz came to Minneapolis from New York City in 1939, when he bought a cigarette vending machine business. A friend told him that Minnesotans loved to hunt, so he bought a hunting outfit and a gun, and went hunting. He shot and killed a pheasant, got sick to his stomach when he saw the dead bird, and immediately headed for home. The next day he sold his gun and his hunting outfit, and never went hunting again! (Courtesy of Anita Schwartz.)

Joseph and Helen Osterman were really excited when they could afford to buy this new automobile. (Courtesy of Jean Minter.)

Two

TEMPLE ISRAEL
MINNEAPOLIS'S FIRST SYNAGOGUE

On October 5, 1878, 23 German Jews living in Minneapolis filed Articles of Incorporation for Congregation Shaarai Tov, which meant "Gates of Goodness." Membership grew rapidly, and on September 5, 1880 they dedicated their first synagogue, a small wooden building on Fifth Street between Marquette and Second Avenue South. Non-Jewish clergy and community leaders joined Shaarai Tov members as they walked the five blocks to the new building, carrying their Torah Scrolls. A choir sang the 24th Psalm, the first three verses of Genesis were read in Hebrew, and speakers praised the "young and aspiring congregation" and the trustees who paid for the building by "doing their best to surpass each other in personal zeal and pecuniary sacrifices."

Shaarai Tov was built on rented land, however, and they had problems renegotiating their lease. In 1888 they moved their wooden synagogue to newly purchased land on the corner of Tenth Street and Fifth Avenue South. When fire gutted the building four years later, they decided to build a fire-resistant stone synagogue, and on December 27, 1903 they dedicated their new building with a ceremonial passing of the key from Building Committee Chairman Henry Weiskopf to Congregation President Abraham Stromberg.

Now Shaarai Tov began to grow more rapidly. In 1907 the membership roster showed 125 families, with 100 pupils enrolled in the Religious School, and by 1914 their building was too small for High Holiday services and for the 200 students attending Sunday School. They rented the Universalist Church and then the Lyceum Theatre for the High Holidays, and paid $14,000 to purchase the Smith family's two-story wooden house, on the corner of 24th and Emerson Avenue South, for Religious School classes and office space. By 1919 there was talk of building a new synagogue, but 275 member families seemed too few to undertake a project that might cost as much as $300,000. But in 1925 there was a fire at the Smith house, and, with the safety of their children at stake, the decision was made to build a new synagogue at 24th and Emerson.

Five rabbis served Shaarai Tov between 1878 and 1900. The first two each left after only one year. Then came Rabbi Henry Illiowizi, 1880-88, who turned Shaarai Tov toward Reform Judaism. Neither the Rabbi nor his congregants covered their heads to worship, Confirmation services for 15-year-old boys and girls replaced the traditional Bar Mitzvah, and Illiowizi conducted public conversions for Christians who wanted to become Jews. Then came Rabbi Samuel Marks, and then Aaron Friedman, who replaced their Orthodox Hebrew *siddur* with the new *Union Prayer Book*. And then, in May, 1901, the congregation hired Rabbi Samuel N. Deinard.

Samuel Deinard was born in Lithuania, grew up in Palestine, and came to Philadelphia at age 20 to study for the rabbinate. He had a warm, genial personality and he spoke eloquently in six languages—Hebrew, Yiddish, Arabic, French and German, as well as English. He became a peacemaker between his congregants and the Orthodox Jews flooding in from Eastern Europe.

Deinard conducted services in English on Rosh Hashonah, and then, because Reform Jews only worshiped on the first day, he would go to North Minneapolis on the second day of Rosh Hashonah to preach in Yiddish to Kenesseth Israel's Orthodox congregation. He founded and edited the *American Jewish World*, and he was a Zionist who encouraged women to start a local chapter of Hadassah and urged his congregants to help the pioneer settlers in Palestine in an era when Zionism was not acceptable to most Reform rabbis and congregations.

Rabbi Deinard also made pioneering changes in his congregation's activities and worship. He proposed that Hebrew be taught in their Religious School. He organized an Attendance Committee to send postcards to members, reminding them to attend Friday evening services and asking them to bring friends. He experimented with Sunday morning services and suggested that a cornet could simulate the sound of the Shofar at High Holiday services, and in 1920 Shaarai Tov members decided to Americanize their house of worship by changing their name to Temple Israel. East European Jews began joining Temple Israel because they were captivated by Deinard's brilliant sermons, the decorous style of worship, and by services conducted in English.

On Yom Kippur, 1921, Rabbi Deinard suffered a fatal heart attack. His stricken congregation chose Albert Minda, who had been ordained three years earlier at Hebrew Union College, as their new Rabbi. He, too, was the son of Lithuanian immigrants and had grown up in an Orthodox Jewish home before turning to Reform. Under his leadership, membership grew and Temple's programs expanded. He revised the Religious School curriculum, set up a joint teacher training program with Mt. Zion Temple in St. Paul, and revised the Confirmation program for 15-year-olds, moving the service to Shavuoth and insisting that "in the interest of democracy" there be one reception for all confirmands at Temple House.

Rabbi Minda was dedicated to what he called the "genius" of the Reform Movement, and he did much to perpetuate that "genius," building bridges between contemporary Judaism and its tradition-filled past to appeal to his congregants' emotions as well as their intellects. He collected Jewish ceremonial objects and Jewish art; and on Friday nights he wore a black robe and read from the Torah, Kiddush was chanted and candles blessed, a cantor and choir sang liturgical music, and members and guests flocked to Temple Israel to hear his brilliant sermons.

Once again, they needed a larger synagogue for their rapidly growing congregation. On March 18, 1927 congregants approved a building plan by architects Liebenberg and Kaplan, and one month later Temple Sunday School children participated in ground-breaking ceremonies for their new house of worship at 24th and Emerson. On June 1, 1928 the congregation worshiped for the last time in their old synagogue at Tenth Street and Fifth Avenue South, and three months later, on September 7, they assembled at their new Temple for a gala inaugural Sabbath service.

City leaders joined in the dedication ceremony for Temple Israel's new house of worship, a dramatic $225,000 building where more than 1,000 people could worship in a sanctuary with excellent acoustics. The pillared facade commemorated the influence of Greek culture on early Judaism, the five sets of doors at the entrance to the sanctuary represented the five books of the Torah, and the twelve columns in the sanctuary signified the twelve tribes of Israel. Egyptian Acanthus leaves in the organ grilles above the bima were a reminder of the Jews' sufferings as slaves in Egypt, and the six windows in the sanctuary were dedicated to six great periods in Jewish history, and to the ideals they represented: the Creation, the Patriarchs, Exodus, the Temple, the Prophets, and post-Biblical ideals of one world and one humanity.

Rabbi Minda introduced many innovative programs, including the annual Interfaith Thanksgiving Service, tours for Christian guests conducted by Jerry Robbins, and a 20-minute Daily Worship Service lead by volunteers, for people who came to say Kaddish for a family member or friend. Following the Depression and World War II, Temple membership grew rapidly, from 406 families in 1945 to 1,250 families in 1963, when Rabbi Minda retired.

Rabbi Max Shapiro came to Minneapolis as Temple's first Assistant Rabbi. He had been teaching in a Boston high school when he was drafted during WW II and assigned to an army

hospital near Atlanta. His commanding officer asked him to serve as Chaplain, and although he had been raised an Orthodox Jew, he decided to use the Reform section of the Armed Forces' Jewish prayer book. When the war ended he decided to become a Rabbi, and chose Reform because it was "the only way to live as a modern Jew."

Max Shapiro was a "personal rabbi" who believed warmth and laughter belonged in the pulpit, and during his tenure the congregation grew to more than 1,700 families, the tenth largest in North America. He encouraged Bar and Bat Mitzvot, created Supplementary Prayer Books for Sabbath and the High Holidays, and introduced contemporary music, but he also continued to read the Torah at Friday night and Saturday morning services. Rabbi Minda had been a community leader as a founding member of the Minneapolis Round Table of Christians and Jews and of the Urban League, both dedicated to promoting brotherhood and combating anti-Semitism. Now, under Rabbi Shapiro, Temple joined nearby churches in projects like the Neighborhood Involvement Program, Interfaith Seders, and Thanksgiving Day morning services at the Basilica of St. Mary. Shapiro was a founder of the Minnesota Council on Race and Religion, and served on a State Commission Against Discrimination, the Minneapolis Committee on Fair Housing, and the Minneapolis Urban Coalition.

Stephen Pinsky, the first Temple Israel Rabbi brought up in the classic Reform tradition, came to Temple Israel as Associate Rabbi in 1981, and became Senior Rabbi in 1985. He was also a traditionalist, however, and was a leader in the national movement to incorporate more Hebrew and more traditional liturgy into Reform Judaism's worship services. He taught Jewish history at Augsburg College, and served on the Board of Minnesota's new International Treatment Center for Victims of Torture, the Mayor's Task Force on Teen-Age Pregnancy, and a national Rabbinic Commission on Synagogue Music. Pinsky also continued Temple's active participation in interfaith dialogue with the Christian community. And now, for the first time, Temple Israel had a fully trained, full-time cantor, Barry Abelson.

After Rabbi Pinsky left Temple to become Midwest Regional Director for the Union of American Hebrew Congregations, Joseph Edelheit was installed as Temple Israel's new Rabbi on October 30, 1992 in a service attended by 23 of his Chicago congregants who came to Minneapolis to say "goodbye" to their beloved rabbi. Rabbi Edelheit was also concerned with the social issues of his era. He worked with President Clinton on a national program to help victims of AIDS. Members of Temple and the Basilica of St. Mary were on a joint tour of Israel when President Yitzhak Rabin was assassinated, and they participated in Rabin's funeral. Edelheit also placed new emphasis on education for adults, creating an informal Saturday morning Torah Study and discussion program that continues to attract Temple members of all ages.

It was during Rabbi Edelheit's tenure that, for the first time, Temple Israel hired women as Assistant Rabbis, Marcia Zimmerman and Andrea London. When Rabbi Edelheit left in 2001 to pursue a new career as an author, and later as director of the new Department for Jewish Studies at St. Cloud State College, Marcia Zimmerman was promoted to Senior Rabbi. She is the first woman Rabbi to lead such a large congregation, and has two young men as Assistant Rabbis, Simeon Glaser and Jeffrey Wildstein. And there is always change, including Shabbat services at 5:45 p.m. during the summer, rather than at 8 p.m.

Today, very few of Temple Israel's families live within walking distance of their house of worship, but their congregation has continued to grow, from 384 families in 1944 to 598 families in 1948, 1,000 in 1958, 1,250 in 1963, and an estimated 1,900 families in 2003. Temple remains one of the ten largest Reform congregations in the United States.

In 1877, the wives and sisters of the men who were already planning their city's first synagogue established the Hebrew Ladies Benevolent Society. They believed that "religion and community service go hand in hand; they're the rent you pay for the space you take up on this earth." They cared for the sick and prepared the dead for burial in the traditional Orthodox Jewish way, and they also helped newly arrived immigrants and the Jewish poor—often one and the same—to find jobs and a place to live, and to adjust to their new lives in America. Then, with a new synagogue building to care for, they became the Shaarai Tov Auxiliary, with a

busy schedule of ice cream socials, card parties, dances, sewing bees, musical recitals, dinners, lectures, and bazaars to educate their members and to raise money to help pay off Shaarai Tov's mortgage. And then, when the United States plunged into the Great Depression just one year after their new synagogue was completed, some members had to cancel their pledges, and many others resigned because they couldn't even pay their dues, and so the Rigadoo was born. Rigadoo, a weekend fundraising bazaar named after a Scottish folk dance, was sponsored by Sisterhood—the new name for Shaarai Tov's Auxiliary—and Men's Club, organized in 1922. During its five-year history Rigadoo netted $25,000, enough to save the Temple and its credit rating. Sisterhood members also began to involve themselves in other congregational activities: Jewish education, interfaith dialogues and meetings, a choir, arranging Seders for the Religious School, and building a Sukkah. They also refurbished the Temple kitchen and helped build and staff the library, cooked dinner for the congregation's annual meeting, and arranged the dessert table for the Oneg Shabbat social hour following Friday night services.

And there are other programs. By 1954 many members were participating in Adult Education classes which meet on Saturday mornings to study and discuss Bible, Hebrew, Jewish history and thought, and current topics. People who wish to commemorate a Yahrzeit or say Kaddish for someone recently deceased can attend the 20-minute Daily Worship Service in Deinard Chapel, conducted by members of the congregation since 1958. Couples Club was organized in 1960, a Single Parents Club in 1964, and the New Horizons Club's social and cultural events for active seniors over 60 began in 1963.

CERTIFICATE OF INCORPORATION OF THE HEBREW CONGREGATION OF MINNEAPOLIS, MINNESOTA, SHAARI TOF

We, Theodore Rees and L. Ehrlich, undersigned members and voters of the Hebrew Congregation of Minneapolis, Minnesota, Shaari Tof (Seekers of the Good), nominated by a majority of the members and voters thereof, who were present, presided and determined the qualifications of the voters of said Congregation and received the votes at an election held September 23rd, 1878, pursuant to notice given August 23rd, 1878, for the purpose of electing Trustees of the Hebrew Congregation of Minneapolis, Minnesota, Shaari Tof (Seekers of the Good), and we do hereby certify that at said election of September 23rd, 1878, the following persons were duly elected Trustees of said Congregation:

LOUIS METZGER
RALPH REES
E. BERNSTEIN
S. SEGELBAUM
GEORGE G. JACOBY

That said Trustees and their successors are and shall be desigeated and known by the name of Trustees of the Hebrew Congregatioi of Minneapolis, Minnesota, Shaari Tof.

That said proceedings and election were had, and held pursuaro to statutes in such case made and provided.

THEODORE REES
L. EHRLICH

Filed October 5, 1878
at 10 o'clock A.M.

Congregation Shaarai Tov members filed their Certificate of Incorporation at the Minneapolis City Hall on October 5, 1878. In English, the name meant "Gates of Goodness." One member said the name was particularly appropriate because they were meeting in a rented room on the third floor of a building at 213 Hennepin Avenue, so they were "nearer heaven than any other congregation in the city!" (Courtesy of Temple Israel.)

18

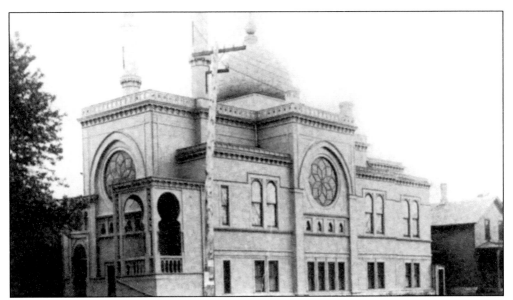

Shaarai Tov members built their first synagogue in 1880, an elegant wooden building on the corner of Fifth Street and Marquette Avenue. (Courtesy of Temple Israel.)

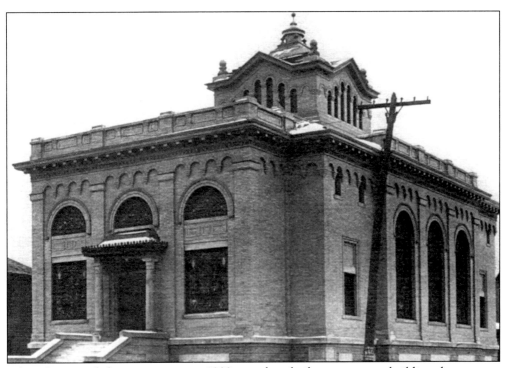

When fire gutted their synagogue in 1902, members built a new stone building that cost an estimated $18,000, a major financial undertaking for a congregation still numbering less than 100 families. The cornerstone was laid on June 14, 1903, and when they dedicated their new building on December 27, just one year after the fire, local newspapers reported the event as "an occasion of solemn splendor." (Courtesy of Temple Israel.)

The Building Committee

Henry Weiskopf,
chairman

Aaron Heller,
secretary

Isaac Weil,
treasurer

Abraham Stromberg
Joseph M. Davis
Leopold Metzger
Simon Gittelson
Rudolph Munzer

Henry Weiskopf chaired the building committee which raised the necessary funding. (Courtesy of Temple Israel.)

Celebrated in the New Synagog
Interesting Ceremonies by Rabbi Stemple of Washington

"On Sunday evening at seven o'clock, the first service was held in the new temple of the Hebrew Reform Congregation on Fifth Street, the occasion being the beginning of the Jewish New Year, 5884. Every seat in the Synagog was occupied, quite a number of those present being Gentiles. The pews were sold by auction by G. L. Levi, who undertook to animate his fellow co-religionists to the tune of $500.00. The first choices were bought by Messrs. Rees, Bernstein, and Rosenband and nearly all the members responded, paying liberally for the choice of their seats, besides contributing largely for the yearly support of the minister and for the building fund. The services were conducted by Rev. Mr. Stemple, Mr. Bernstein, the president, Mr. Schreiber, the former pastor being on the rostrum. The services consisted of the regular ceremonies of their holidays, the New Year.

"Prof. Larsen accompanied the choir on an organ from Mr. Penfield's music store. The solos and duets were sung by the Misses Jacobs who formerly belonged to the synagog choir at Oil City, Pa. and deserve the greatest praise.

"The sermon, a short one, was truly interesting and expounded the doctrines of Judaism which tho not despising the doctrines of other religions, claims for itself the first place. He said 'We have erected a house of worship of Israel, not only to show that the Mother of Christianity is not to be despised altho she is old. The mother remembers well her duty to her daughters, inviting them to the universal shrine of worship.' The services were impressive and the beautiful prayers of the Philadelphia Prayer Book were rendered with due solmenity. Praises are due to such a small congregation for their grand effort in erecting and sustaining such a place of worship which is a pride to themselves and to the city.

Messrs. J. Skoll, R. Rees, and Geo. Jacoby, ushers, did all in their power to seat the throng and make them comfortable. New Year services of a similar character were held at ten o'clock Monday morning. The public dedication of this Temple will take place in five or six weeks and will be duly announced."

The *Minneapolis Morning Tribune* reported in detail on the congregation's celebration of the Jewish New Year at their new synagogue. (Courtesy of Temple Israel.)

Members of the Ladies Auxiliary and their husbands performed as the Tuxedo Minstrels in Shaarai Tov fundraisers held at the Masonic Temple. Members of the group included Lou Hedra, Louis Taussig, Sam Bresky, Herbert and Irma Wilk, George Evans, Gus Weingarten, Minnie Shapiro, Ruth Heller, Florence and Sylvia Simon, Samuel Cutts, Odessa Rosenstein, Max Levy, Jesse Hyman, Sidney Kaufman, Carl and Grace Davis, Elsa Jacobs, Gladys Moss, and Inez Rees. (Courtesy of Temple Israel.)

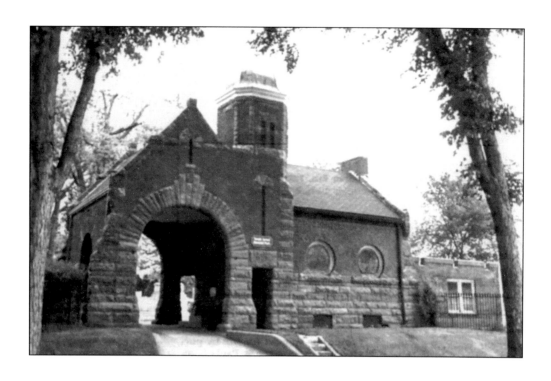

Montefiore Cemetery Association

TO

Leo Monasek

Office of Montefiore Cemetery Association.

County of Hennepin, Minn.

I hereby certify that the within Deed was filed in this office for record on

the _15th_ day

of _July_ A. D. 19 _14_

at _4_ o'clock _P_ M., and was duly

recorded in Book _1_ of Deeds.

page _82_

Secretary.

The chapel built by the Montefiore Cemetery Association, founded in 1876, is at the entrance to what is now Temple Israel Memorial Park. Located at Forty-Second Street and Third Avenue South, it is the only Jewish cemetery within the Minneapolis city limits. (Courtesy of Temple Israel.)

As Minneapolis grew and Shaarai Tov members prospered and left their downtown row houses to move into newly built homes south of downtown, congregants wanted their synagogue moved to a more convenient location. (Courtesy of Temple Israel.)

Wanted – a new Temple

At the general congregational meeting held on April 2, 1911, a committee was appointed to look for a site on which to erect a new Temple edifice in a district more convenient to the members. A mortgage was to be placed on the present Temple. Various sites were investigated but none appeared satisfactory.

In the meantime, at the Board meeting, January 8, 1914, Mr. John Friedman, a Temple member offered the premises at 24th Street and Emerson Avenue South (the old Smith residence) for the purchase price of $14,000.00. The Deed of Conveyance was to contain a provision that the premises should be used to erect thereon a House of Worship and for other congregational purposes. The generous offer was accepted and the residence was rehabilitated to the needs of Religious School classes and also for community needs.

On November 16, 1919, the Building Committee was instructed to build one wing for Religious School purposes, the cost of which was not to exceed $100,000.00. The entire Temple was to cost $300,000.00.

Mr. I. K. Kaufman, who was Chairman of the Building Committee, reported to the Board of Trustees on April 6, 1924, that the time was inappropriate for the building of a new Temple.

The building project remained dormant until the year 1925. During that year, a fire broke out in the wooden Temple House where we held our Religious School classes.

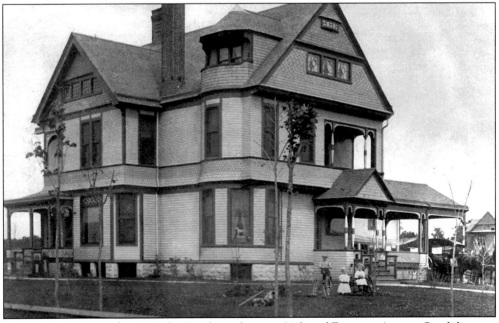

Purchased in 1914 for $14,000, the Smith residence at 24th and Emerson Avenue South became Shaarai Tov's religious school and administrative office. (Courtesy of Temple Israel.)

Program

Cornerstone Laying Ceremony Temple Israel

July 17, 1927

━━●✕●━━

JONAS WEIL, Presiding

Invocation Dr. Alexander Basel

Remarks of Welcome Jonas Weil

Description of Building Project . Simon Meyers

Corner Stone Laying Address Rabbi Albert G. Minda

Reading of Service Jonas Weil

Reading of History of Congregation, Ralph Hamburger
Written by Mrs. Henry Weiskopf

Cornerstone Laying and depositing of documents in stone
Ralph Hamburger

Benediction . . . Rabbi Joseph Utschen

On July 17, 1927, members of Shaarai Tov, now known as Temple Israel, laid the cornerstone for their new synagogue. In September, 1928, they celebrated completion of their new building at a Friday Evening Service, a Saturday Morning Service for the Religious School and Junior Congregation, a Sunday evening program with clergy from neighboring churches, and a Jubilee Dinner that also celebrated the congregation's 50th anniversary. (Courtesy of Temple Israel.)

TEMPLE ISRAEL
Minneapolis, Minnesota
Dedication Program

Fellowship Service

Sunday Evening, September 9th, Eight O'clock

ORGAN PRELUDE—"Adoration" Borowski
ANTHEM—"Sing to The Lord" Harker
INVOCATION
INTRODUCTORY REMARKS
 RABBI A. G. MINDA
GREETINGS
 In Behalf of Minneapolis
 DR. M. D. SHUTTER
 Church of The Redeemer
 Msgr. J. M. CLEARY
 Church of the Incarnation
FELLOWSHIP PRAYER
VIOLIN SOLO—"Adagio" from Suite No. 3 Ries
 MARION BAERNSTEIN BEARMAN
GREETINGS
 In Behalf of Beth El CongregationRabbi David Aronson
 In Behalf of Minneapolis Federation of Churches
 Dr. P. S. Osgood
 St. Mark's Episcopal Church
 In Behalf of Minneapolis United Orthodox Synagogues
 Rabbi Moses Romm
ANTHEM—"How Lovely Are the Dwellings"Liddle
NEIGHBORHOOD GREETINGS
 DR. DAVID BRYN-JONES
 Trinity Baptist Church
 RABBI JESSE SCHWARTZ
 Adath Yeshurn Synagogue
ANTHEM—"Arise, Shine" Foote
BENEDICTION
POSTLUDE

The Congregation Jubilee Dinner commemorating the fiftieth anniversary of the founding of Temple Israel will take place on Monday evening, September tenth, at six-thirty o'clock in the auditorium of the Community House.

TEMPLE ISRAEL PLANS FOUR-DAY DEDICATION FETE

Exercises to Be Held Sept. 7-10

Building to Be Presented to Flock at Formal Service Friday

JUBILEE DINNER SET FOR MONDAY

Other Faiths to Extend Greetings at Meeting Sunday Night

Exterior View of $400,000 Temple Israel and Community House

New $400,000 Temple Israel with a community house adjoining the the left.

New Church Cost Flock $400,000

Building Group Chairman Discusses Development of Project

VOLUNTEERS RAISE FUND OF $175,000

Ground Broken in 1927— Edifice Finished in Year and Half

AUDITORIUM IN NEW SYNAGOGUE TO SEAT 1,400

Altar Situated in Middle of Side of Greatest Length

Trinity of Synagogue's Traditional Ideals Incorporated in Temple, Says Rabbi Minda

By ALBERT G. MINDA

SIX MINISTERS SERVED CHURCH IN 50 YEARS

Rabbi Minda Has Served Congregation Since 1922

TEMPLE ISRAEL OLDEST JEWISH CHURCH IN CITY

Was Organized in October, 1878, as Temple Shaari Tov

SCOUT TROOP NO. 18 HAS GOOD RECORD

JUNIOR GROUP IN CONGREGATION

SCIENCE ROUTS ECHOES FROM AUDITORIUM

All Surfaces Are Treated With Materials to Absorb Reverberations

SISTERHOOD AIDS RELIGIOUS SCHOOL

EN'S CLUB WILL EQUIP GYMNASIUM

Officers, Trustees of Temple Israel

They Were Guiding Spirits in Temple Israel Building Project

They Had Charge of $400,000 Project

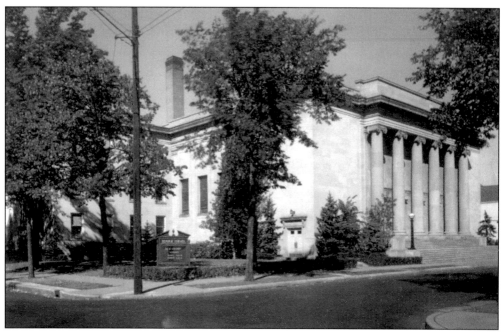

Architect Jack Liebenberg designed many public buildings, including art deco theaters which are now on the Historic Register. He called his design for Temple Israel, a contemporary building with a chapel seating some 1,000 people, "an unfinished symphony—a building that could grow and change." (Courtesy of Temple Israel.)

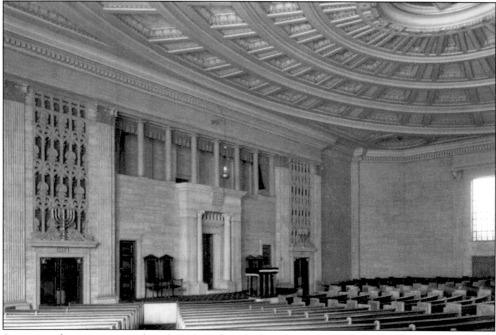

Some members were upset by what they described as the sanctuary's "polka-dot" ceiling, but it was actually a pioneering installation of a new invention called acoustical tile, which continues to make Temple Israel an ideal location for concerts and other events. (Courtesy of Temple Israel.)

In February, 1930, with the Depression causing a shortfall in members' contributions, Temple purchased Mortgage Bonds to help pay for their new building. Within seven years, however, they had paid off their mortgage, and at their June, 1937, annual meeting, they celebrated by burning their mortgage documents. (Courtesy of Temple Israel.)

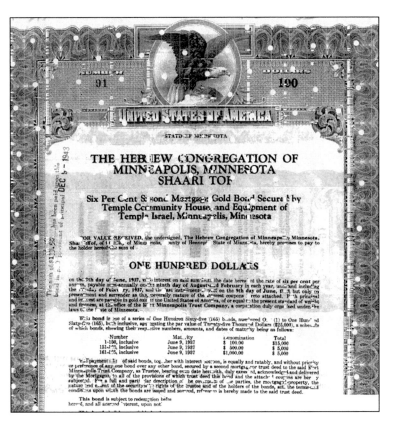

The President's Message - - - - Mr. I. S. Joseph

Nomination and Election of Officers and Board of Trustees

CEREMONY – BURNING OF MORTGAGE

Mr. Amos S. Deinard, Presiding

Reading of Psalms of Thanksgiving

Anthem - - - - - - - Temple Choir

Presentation of Mortgage Documents by - Mr. I. S. Joseph

First Mortgage - - - Mr. Simon Meyers
Vice-Chairman of Building Committee

Second Mortgage - Mr. Irving H. Robitshek
Past President

THE BURNING OF MORTGAGE DOCUMENTS

Anthem - - - - - - - Temple Choir

Concluding Remarks and Benediction - Rabbi Minda

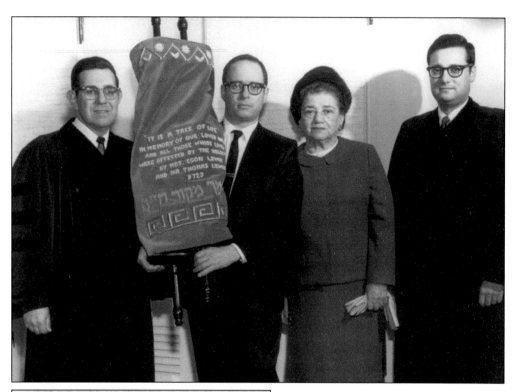

DEDICATION OF TORAH

RESCUED FROM CZECHOSLOVAKIA

GIVEN TO TEMPLE ISRAEL

IN MEMORY OF THEIR LOVED ONES

AND ALL THE OTHERS WHOSE

LIVES WERE AFFECTED BY THE HOLOCAUST

. BY

MRS. EGON LEWIN AND MR. THOMAS LEWIN

☆ ☆ ☆

The Torah is central to Judaism. It symbolizes for us the way man shall live. This Sanctuary beautiful though it may be - would be but an auditorium without the Ark and the Torahs that rest in it. Any room in which the Torah is present becomes a holy place - a place for worship.

This Sabbath Eve, we as a congregation are honored and privileged to bear witness to the presentation and dedication of a new Torah. It is presented in memory of their loved ones and all the others whose lives were affected by the Holocaust by Mrs. Egon Lewin and Mr. Thomas Lewin, and it has special significance. It is perhaps the most fitting memorial that one can give. Much in life changes. Men grow old and die. Buildings crumble. The flower withers. But man's spiritual creations live on - and the Torah is the height of such creativity. It is preserved from age to age - transmitted from generation to generation. Even when it is worn- even when it can no longer be read, it is never destroyed but carefully preserved.

The Nazis stole hundreds of Torahs during World War II for a "Memorial" they planned to build after the war to celebrate the destruction of the Jews. Shown here with Rabbis Max Shapiro and Herbert Rutman are Nanette Wasserman Lewin, who escaped from Berlin in 1940, and her son, Thomas Lewin, who left Berlin in 1939, spent the war years in England, and came to Minneapolis in 1945. They sponsored purchase of this Torah from Tabor, Czech Republic as a gift to Temple Israel. (Courtesy of Temple Israel.)

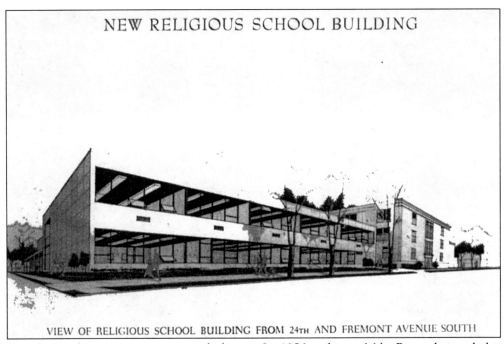

NEW RELIGIOUS SCHOOL BUILDING

VIEW OF RELIGIOUS SCHOOL BUILDING FROM 24TH AND FREMONT AVENUE SOUTH

Temple Israel continues to grow and change. In 1956 architect Milo Bentz designed this addition to house the Religious School and Day Care facility. (Courtesy of Temple Israel.)

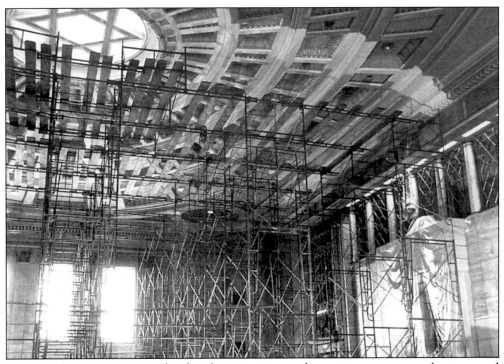

In 1977 the sanctuary was updated with new seating and carpeting, a new sound system, and a redesigned bima to accommodate members of the congregation who now participated in the Friday evening worship service. (Courtesy of Temple Israel.)

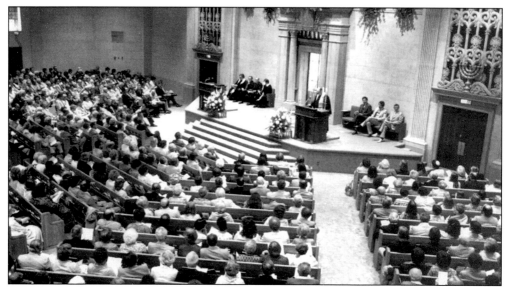

Temple congregants gathered to celebrate the completion of the sanctuary's remodeling and redecorating. (Courtesy of Temple Israel.)

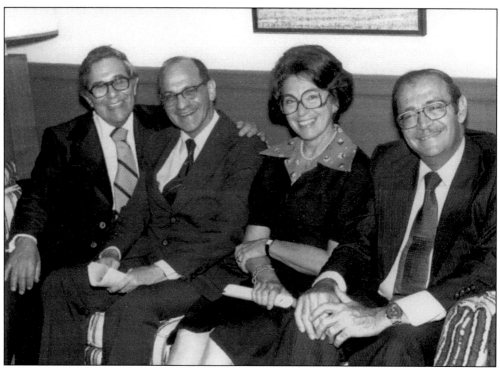

The following year, on May 26, 1978, Temple Israel celebrated its 100th anniversary—and the State of Israel's 30th anniversary—with Simcha Dinitz, Israel's Ambassador to the United States, as guest speaker. Pictured from left to right are Rabbi Max Shapiro, Temple members Burton Joseph and his wife, Geri Joseph (former United States Ambassador to the Netherlands), and Simcha Dinitz. (Courtesy of Temple Israel.)

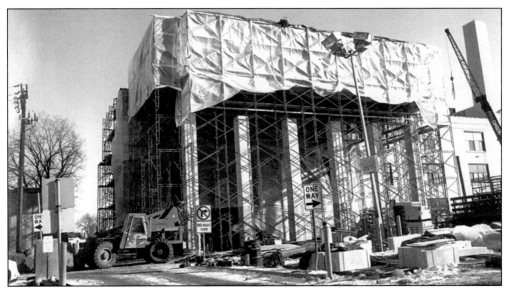

In 1986 construction began on another building addition. Designed by architects Milo Thompson and Frederick Bentz, it includes a new entry from the parking lot that is a modernized "mirror image" of the entrance on Emerson Avenue, with a portico to shelter wedding parties and funeral vehicles. The addition also includes a 250-seat theater, elevators to make the building more handicapped-accessible, additional offices and classrooms, and an expanded library. (Courtesy of Temple Israel.)

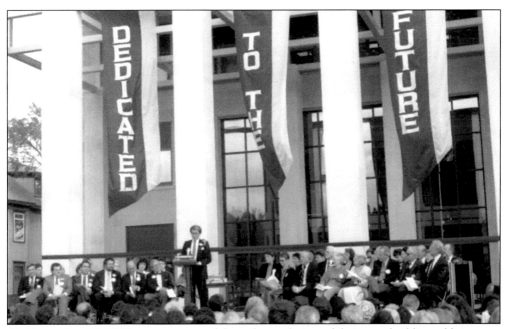

On September 20, 1987, congregants celebrated completion of their new building addition at a gala outdoor ceremony. (Courtesy of Temple Israel.)

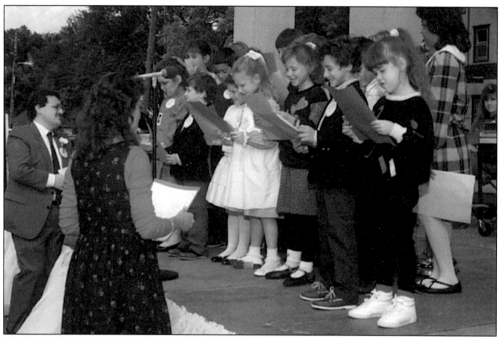

Children from Temple's Religious School participated in the ceremony, lead by Cantor Barry Abelson. (Courtesy of Temple Israel.)

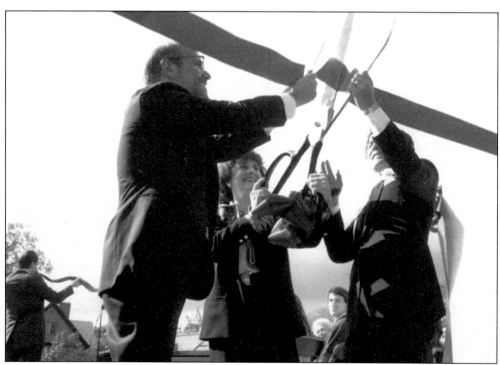

The Dedication Ceremony concluded with the blowing of the shofar and celebratory ribbon-cutting by Rabbi Stephen Pinsky, Congregation President David Abramson, and Dolly (Mrs. Edward) Fiterman. (Courtesy of Temple Israel.)

In 1901 Rabbi Samuel N. Deinard came to Congregation Shaarai Tov, beginning an era of great progress and change. He Americanized the style of worship, and in 1920 the congregation changed its name to Temple Israel. But then, on Yom Kippur eve, 1921, Rabbi Deinard died suddenly and unexpectedly of a heart attack. (Courtesy of *American Jewish World*.)

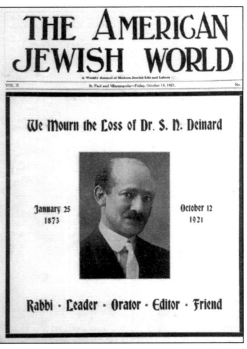

Rabbi Deinard pioneered in community involvement. He lectured to Stillwater State Prison inmates, church groups, and the Hennepin County Equal Suffrage Assn. He represented Minnesota at the National Conference of Charities and Corrections and was the first president of the Minneapolis chapter of the NAACP. He served on the Minneapolis Board of Education, Community Chest Council, Committee on Unemployment, and Civic and Commerce Assn. Hundreds of congregants and community leaders gathered for Rabbi Deinard's funeral and the procession to the cemetery. (Courtesy of Temple Israel.)

33

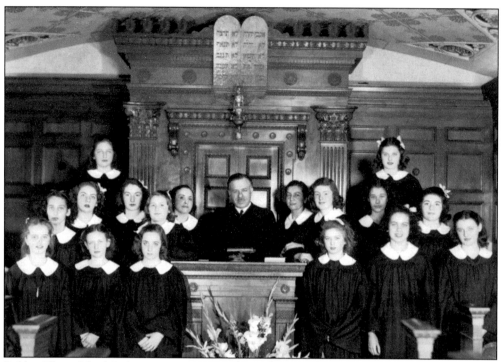

Rabbi Albert Minda's focus on young people's religious education and activities included a Young People's Choir that sang at Saturday morning services in the Deinard Chapel. Choir members included Lois Swiler Rose, Babette Litton Fischbein, Joyce Herzog, Betty Mae Beugen Parker, Connie Yaeger, Florence Kunian Schoff, Marilyn Weiner Engel, and Jean Ellis Minter. (Courtesy of Jean Minter.)

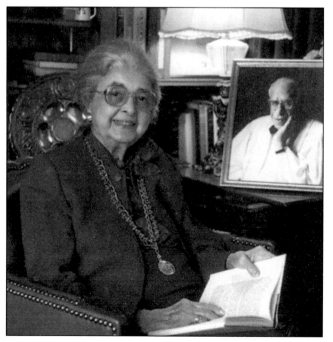

Frances Minda, Rabbi Minda's wife, assumed a very active role in Temple Israel programs and in the larger community. After her husband retired in 1963 their home became an archive for a remarkable collection of Temple and community history. (Courtesy of *American Jewish World*.)

Rabbi Max Shapiro came to Temple Israel in 1955 and began his 22 years as Senior Rabbi when Rabbi Minda retired in 1963. He, too, was a people-oriented rabbi dedicated to serving both his congregation and the community. He was a founder of the Minnesota Council on Race and Religion, served on the State Commission Against Discrimination and the Minneapolis Committee on Fair Housing, and represented Minnesota at the funeral of Martin Luther King, Jr. In 1981 he was honored as one of the Twin Cities' "10 most influential clergy," and in 1985, as Rabbi Emeritus, he became director of the new Center for Christian-Jewish Studies at St. Thomas College. (Courtesy of *Minneapolis-St. Paul* magazine.)

MPLS.ST.PAUL JANUARY 1981

Max Shapiro: "Churches coming together on issues they can agree on can do a great deal."

Max Shapiro

After 25 years, Temple Israel and Rabbi Max Shapiro have become so entwined that it's impossible to talk about them separately. Even he acknowledges, "I'm all wrapped up here. When you talk about my influence, Temple Israel's influence...it's almost the same thing."

Shapiro and his congregation stand firmly in the Jewish Reform tradition, which teaches that concern for the total community is as important as concern for the congregation.

The short, stout, smiling rabbi hasn't let the 1,800 families of Minneapolis's Temple Israel forget that. He has reminded, coaxed and prodded them into action, in burying antisemitism in the 1950s, in championing civil rights for racial minorities in 1960s, in combating neighborhood deterioration, pornography and sexism in the 1970s. He's already sounding a new theme for the early 1980s: the dangers of the political and religious New Right.

"I preach on issues," Shapiro says. Though he staunchly upholds the principle of separation of church and state, he doesn't shy away from themes that are "tangentially on politics."

If he did no more, he would create ripples that would be felt in the larger community. The man or woman who stands in the pulpit of Temple Israel addresses the largest and arguably the strongest Jewish congregation in the Upper Midwest. His words are heard by community leaders the likes of Harvey Mackay, Rudy Boschwitz, Max Winter, Burton and Geri Joseph and Arthur Naftalin. Shapiro regularly publishes his sermons, giving them still wider circulation.

But Shapiro does more. In the late 1960s he chaired a city committee on

mixed results. In 1980 he protested when prayers were allowed at a Bloomington public high school's graduation exercise.

He's adjunct professor of American Judaism at United Theological Seminary in New Brighton. He's a popular guest lecturer at a number of Christian churches. He's a founder of the Minneapolis Urban League, the Downtown Council of Churches and the Minneapolis Council on Religion and Race.

He's also 63 years old—and though the years don't seem to have diminished his energy, they may have tarnished his idealism about how much churches can —or will—do to change society.

"The religious voice can have a tremendous influence in a community... but the only time we've had impressive clout was when we joined together on a common issue, like civil rights," he said recently. "The problem is that the churches don't agree on very many things. Churches coming together on issues they can agree on can do a great deal. I'm constantly searching for such issues."

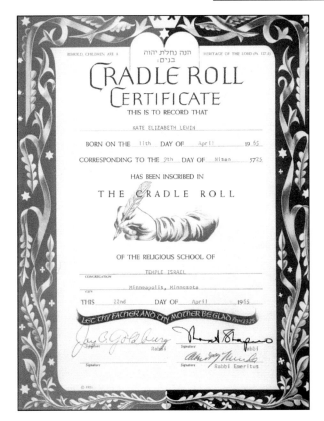

One of Rabbi Shapiro's new ideas for "connecting" with his congregation included the Cradle Roll Certificate, to be presented to newborn members. (Courtesy of Kate Lewin Shamblott.)

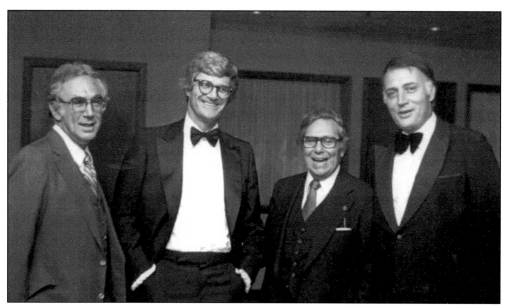

Members of the community joined in celebrating Max Shapiro's 25th anniversary as rabbi at Temple Israel. Pictured from left to right are Rabbi Robert Shapiro, U.S. Senator and Temple member Rudy Boschwitz, Rabbi Shapiro, and U.S. Senator David Durenburger. (Courtesy of Temple Israel.)

Rabbi Shapiro also pioneered in creating Children's and Interfaith Seders, to teach Temple Israel's children and the larger community, including members of neighboring churches, the history of Passover. (Courtesy of Temple Israel.)

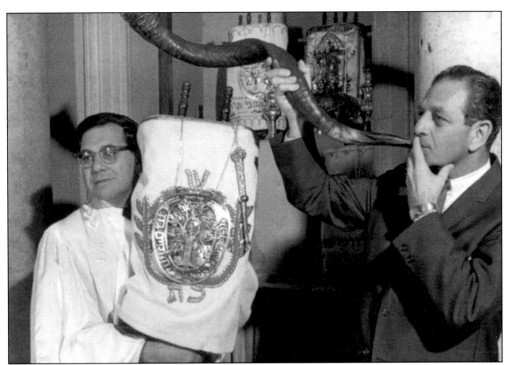

On Rosh Hashonah, 1984, Rabbi Shapiro held the Torah while Harold Goodman blew the shofar, which had become a tradition during the High Holidays. (Courtesy of Temple Israel.)

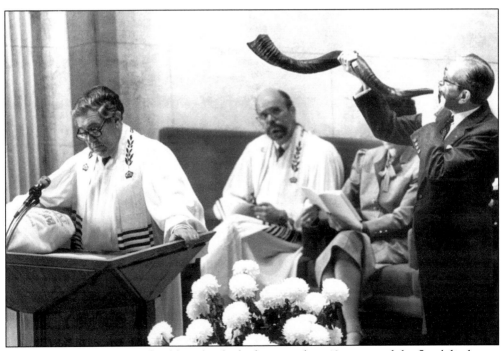

Harold Goodman continued to blow the shofar for more than 40 years, and the floral display on the bima is also an ongoing tradition. (Courtesy of Temple Israel.)

A Word of Welcome	*David H. Abramson, President, Temple Israel*

Leonard W. Levine
Commissioner of Minnesota Department of Human Services,
St. Paul, Minnesota (Representing Governor Rudy Perpich)

Myron Pomerantz
Board Member, Union of American Hebrew Congregations;
Past President, Temple Beth-El of Great Neck, Great Neck, New York

Rabbi Alan D. Bregman
Regional Director, Chicago Federation/Great Lakes Region,
Union of American Hebrew Congregations, Chicago, Illinois

Sim Shalom	*Cantor and Choir*
Installation Address	*Jerome K. Davidson*
	Senior Rabbi, Temple Beth-El of Great Neck
Installation	*Max A. Shapiro*
	Rabbi Emeritus, Temple Israel
Priestly Benediction	*Cantor and Choir*
Response	*Rabbi Stephen H. Pinsky*

Pictured is a segment of the program for Installation of Rabbi Pinsky. Stephen Pinsky was appointed Senior Rabbi in 1985, when Rabbi Shapiro retired. His wife, Lisa, and their son and daughter, Seth and Kira, participated in his installation. (Courtesy of Temple Israel.)

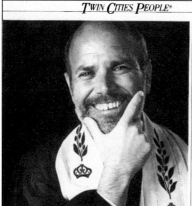

TWIN CITIES PEOPLE

STEPHEN PINSKY

"It is a task of a Jew to try to repair the world. I think Jews have learned that only in a tranquil society is their survival ensured."

Like his predecessors, Rabbi Pinsky was also a community activist. He called himself an "old-style liberal" committed to the Jewish tradition of *tikkun olam* (repairing the world). He was a founding member of the Center for Victims of Torture and chaired NIP, the Neighborhood Involvement Program, a coalition with five neighboring churches organized to care for needy members of their community. (Photo by Layne Kennedy, courtesy of Bonnie Gainsley.)

Rabbi Joseph Edelheit came to Temple Israel as Senior Rabbi in 1992. His focus on community action included co-chairing the national UAHC (Union of American Hebrew Congregations) Committee on AIDS, and he traveled to Washington with other community leaders to discuss the country's growing AIDS epidemic with President Clinton. (Courtesy of Temple Israel.)

A Shabbat Service
in celebration of the
INSTALLATION
of
JOSEPH A. EDELHEIT
as Senior Rabbi of

Temple Israel

October 30, 1992 • 3 Cheshvan, 5753

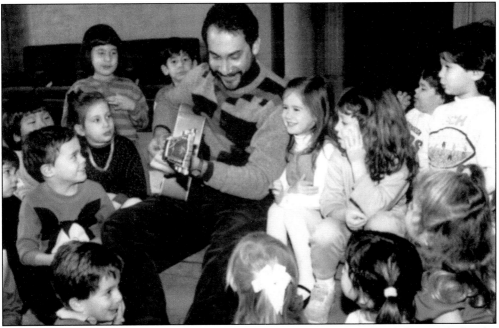

After a successful career on a children's television show, Joe Black decided to study for the rabbinate. In 1987 he came to Temple Israel as the congregation's first guitar-playing Rabbi, and many Temple members, and the children he worked with in the religious school and day care, were very disappointed when he left in 1996 to become Senior Rabbi at Congregation Albert in Albuquerque, NM. (Photo by Bette Globus-Goodman, courtesy of Temple Israel.)

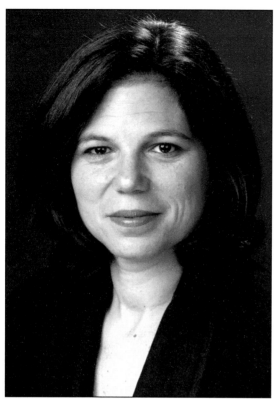

Temple Israel also pioneered in recognizing the growing presence of women in the rabbinate. In May, 1988, Marcia Zimmerman, who had grown up in St. Louis but attended Macalester College in St. Paul, came to Temple Israel as the first woman rabbi in Minneapolis. Today she is Temple's Senior Rabbi, and her husband, Frank Hornstein, was elected to the State Legislature in 2002. (Courtesy of Temple Israel.)

Educating their children in Judaism has always been a priority at Temple Israel. Rabbi Deinard's son, Amos, was confirmed at Shaarai Tov in 1912. (Courtesy of Temple Israel.)

Order of Service

Reading of the Ritual, Union Prayer Book,
pp. 164-200

Processional - - - - Organist

Confirmation Hymn - - - Choir

Opening Prayer - - Justin Cohen

Response - - - - - Choir

Floral Offering - Bessie Blumenson

Duet—Folk Song - - - - Friml
Violin and Organ

Examination of Class in Catechism.

En Komokho - - - - Choir

Address, "The Torah," - Hannah Pam

Reading from the Torah - The Rabbi

Hodo Al Erets - - - - Choir

Reading of Pentateuch Lesson—
Chas. Milkes

Reading of Lesson from the Prophets—
Justin Cohen

Anthem, Still, Still with Thee - Foote

Order of Service

Declaration of Faith - Margaret Marcus

Address to Parents - Celia Friedman

Address to Congregation—
George Friedman

Solo, Adore and Be Still - Gounod
Mr. McCracken

Sermon and Blessing - - The Rabbi

Closing Prayer - - Chas. Milkes

Violin Solo, Meditation from Thais—
Massenet
Mrs. Bearman

Adoration and Kaddish, Union Prayer
Book, p. 224

Anthem, O God, Thou Art Our God—
Bach—Gounod
Soprano Solo and Violin Obligato

Benediction.

Organ Postlude.

1916

Congregants were actively involved in Shaarai Tov's worship services. (Courtesy of Temple Israel.)

Confirmation Class of 1925

CONFIRMANT	ADDRESS	PARENT
Phyllis Beskin,	4620 Washburn Ave. S.	Benjamin
Felix Dreyfuss,	1210 Morgan Ave. N.	Herman
Arnold Golling.	2509 Grand Ave.	Louis
Harold Golden,	2630 Pleasant Ave.	Morris
Leah Kiefer,	4732 Lyndale Ave. S.	Benjamin
Felicitas Klein,	1136 Fourth N.	Simon
Marion Klugman,	1121 Upton Ave. N.	Louis
Minnie Meleck,	1101 Queen Ave. N.	Harry
Sylvia Richards,	3159 Harriet Ave. S.	Louis
Lois Rosoff,	1030 Irving Ave. N.	Daniel
Charlotte Schwartz,	41050 Harriet Ave. S.	Max

Class Motto

"Let Justice Roll Down as Water and Righteousness
as a Mighty Stream."

Confirmation Service

of

Temple Israel

Minneapolis, Minnesota

Sunday
May 31, 1925--5685

The addresses on this 1925 Confirmation program indicate how the Reform movement had grown. North Minneapolis was primarily home to East European immigrants who had founded the North Side's Conservative and Orthodox synagogues, but now they, too, were joining Temple Israel. (Courtesy of Temple Israel.)

The *Templarian* focused on young peoples' involvement in Temple's programs and activities. (Courtesy of Temple Israel.)

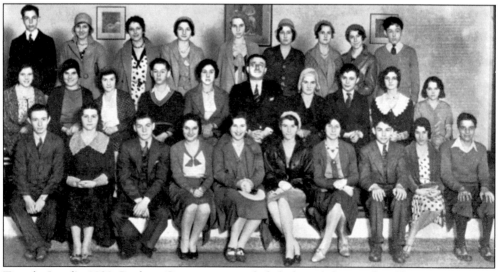

Temple Israel's 1930 Student Government included, from left to right: (front row) Robert Robitshek, Andrew Golling, Justin Rosenblatt, Ruth Kaplan, Marguerite Shalett, Ruth Rauch, Rachel Brin, Robert Levinson, Rita Harris, and Jack Rosenstein; (second row) Muriel Davis, Leontine Robitshek, Bernice Rauch, treasurer Lionel Brill, president Janice Berman, Rabbi Minda, Betty Blumenkranz, vice-president Hershel Gruenberg, Serna Glassberg, and Irma Golden; (third row) Stanley Rose, Raleigh Shandling, Doris Winthrop, Elsa Freeman, Jane Levin, June Gordon, Francis Miller, Rosella Miller, and Howard Lewin. (Courtesy of Temple Israel.)

Members of Temple Israel's first Confirmation Class, in 1923, posed in front of Temple House, where their classes were held. (Courtesy of Temple Israel.)

As the years passed by, graduates began to wear gowns for their Confirmation Service, and their printed programs became works of art. Audrey Mack, Class of 1962, wrote the Introduction for her Confirmation Program: "What does Confirmation mean? I felt for the first time that I was no longer a child being made to go to Religious School; now I had officially accepted Judaism as my religion and was a part of the congregation. Confirmation is a new and inspiring beginning." (Courtesy of Temple Israel.)

CONFIRMATION SERVICE

TEMPLE ISRAEL
Minneapolis, Minnesota

"If it is your will. . .

it will not be a dream."

– Herzl.

SHAVUOT 5741

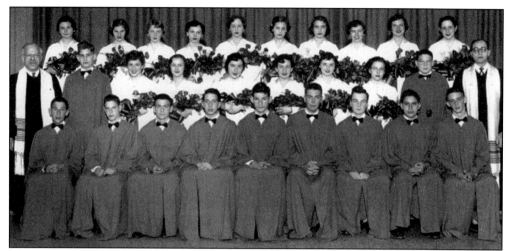

The Confirmation Class of 1952 celebrated its 50th reunion August 2, 2002. Pictured from left to right are: (front row) Matthew Greenberg, Robert Beugen, Neil Feinberg, Murray Galinson, Matt Baskin, Dr. Steven Howard, Nolan Valene, Gary Rappaport, and Michael Goldman; (second row) Rabbi Minda, Dr. Bruce Howard, Marilyn Olstein Greengard, Carol Bierstein Sax, Barbara Balkin Kirschner, Lois Gifis Johnson, Harriet Nemerov Winston, Nancy Goodman, Cal Lewis, and Rabbi Sim Heller; (back row) Mimi Kronick, Evelyn Howard, Saralee Dworsky Mogilner, Judy Gendler Beris, Marilyn Cohen Abrams, Nancy Mayeron Solomon, Judith Lewin Chauss, Dr. Betsy Berman Applebaum, Marion Gottlieb Thornton, and Judy Bierman Katz. Half the class members now live in California, but almost all attended the reunion. (Photo by Ivan Kalman.)

By 1968 Confirmation classes had more than doubled in size. (Courtesy of Temple Israel.)

Participating in the 1989 Confirmation ceremony were Rabbis Stephen Pinsky and Marcia Zimmerman (left) and Rabbi Joe Black and Cantor Barry Abelson (right). (Courtesy of *American Jewish World*.)

Photos of Confirmation Classes now line the hallway outside Temple Israel's social rooms. The class of 2002 included, from left to right: (front row) Rabbi Wildstein, Marlene Goldenberg, Ali Greer, Stacy White, Maddie Thomson, Stephanie Pollack, Victoria Maneev, Brianna Sullivan, Ayelet Grunes, Sarah Rosenstone, Jessie Shiffman, and Rabbi Zimmerman; (second row) Laura Schwartz Harari, Sammi Engler, Olga Yamnik, Alli MacDonald, Alli Bloom, Jordan Isaacs, Alexie Aberman, Leigh Knopf, Rachel Korman, Allie Markman, Dara Cochran, Sasha Launer, Dana Brown, and Cantor Abelson; (third row) Andrew Zidel, Rabbi Glaser, Andrew Blumenberg, Jordan Swiler, Scott Donaldson, David Rhein, David Silverman, Zach Chazin, Paul Chodosh, Ben Becker, Steven Zwick, Jack Weiss, and Education Director Wendy Robinson Schwartz; (fourth row) Jacob Schak, Jared McMorris, Charley Daitch, Ben Stein, Michael Baill, Sam Chazin, Dan Mendelsohn, Scott Stone, and Sam Colich. Not pictured are Daphne Fruchtman, Samantha Morem, Tedi Rappaport, Nathan Ratner, and Abbie Sitkoff. (Courtesy of Temple Israel.)

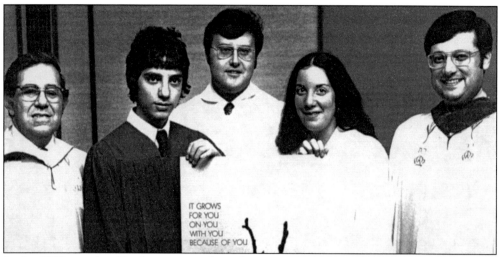

In the 1970s another Confirmation tradition began—a student competition to design a poster for their class. The 1973 confirmands Richard Wolkoff, Robert Fisher, and Elizabeth Bass proudly display their class poster. (Courtesy of Temple Israel.)

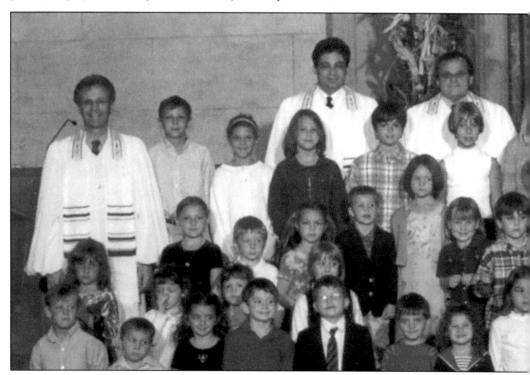

The 2002 Consecration Class included, from left to right: (front row) Noah Haberman, Jaime Posnansky, Sophia Frank, Noah Rothschild, Noah Goldstein, Myles Moss, Samantha Freeman, Olivia Katz, Julia Laden, Micaela Yarosh, Anna Moskowitz, Sophia Munic, Hannah Fine, Ana Siegel, Harry Rothberg, Nathan Richman, and Brandon Herman; (second row) Hannah Magarian, Anna Storm, Laurel Storm, Leah Seal-Gray, Josie Shapiro, Claire Butwinick, Liam Bronstein, Jacob Toffler, and Eli Makovetsky; (third row) Rabbi Glaser, Taylor Lieber, Hunter Meyer,

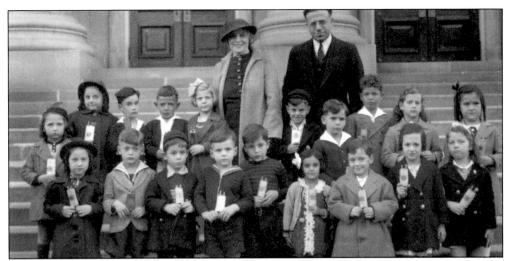

Consecration Service for kindergarteners during Sukkot is also a tradition. Holding the tiny Torahs they received were Rabbi Minda's class of 1937. (Courtesy of Temple Israel.)

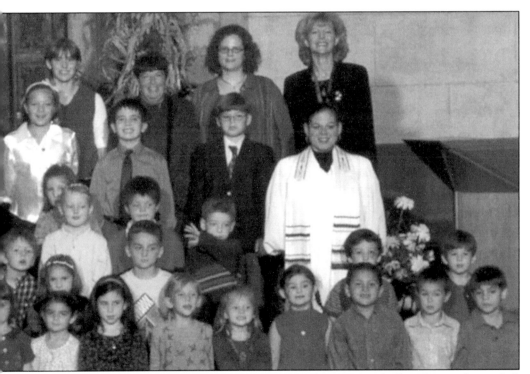

Libby Jacobson, Anthony Morantz, Aliza Beverage, Rebecca Ryweck, Ezra Sergent-Leventhal, Alec Englander, Gustav Palmquist, Sophia Harrison, Frank Culhane, Isaac Frank, Gabe Cohn, and Rabbi Zimmerman; (fourth row) Jack and Jenna Probst, Gabby Greysdorf, Max Berg, Tasha Liberman, Rachel Haukkala, Jorah Cohen, Adam Lurie, and Michael Lieber; (top row) Rabbi Jeffrey Wildstein, Cantor Barry Abelson, kindergarten teachers Liz Kent, Sarene Silver, Amanda Tranby, and Religious School Director Darcy Schnitzer. (Courtesy of Temple Israel.)

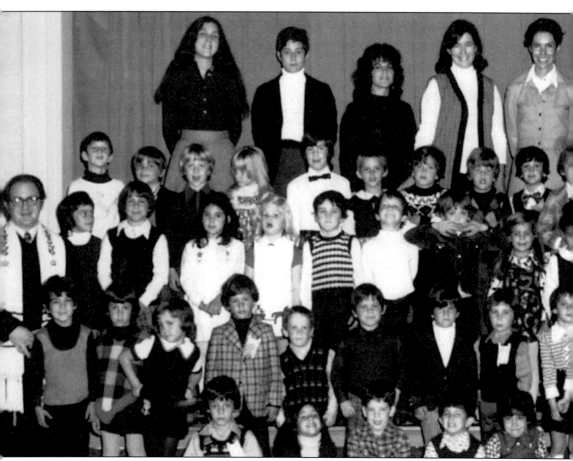

Teaching staff for this 1973 Consecration Class included Joanne Blindman (center, back row), who also served as director of the Temple Israel Nursery School for many years.

In the 1960s and 1970s, Dorothy Sipkins (left, holding the bunny rabbit) was director of Temple's Nursery School, providing educational day-care for children of working parents. (Courtesy of Temple Israel.)

(Courtesy of Temple Israel.)

By 1983–84 enrollment in Temple's Nursery School had grown significantly, and continues to grow. (Courtesy of Temple Israel.)

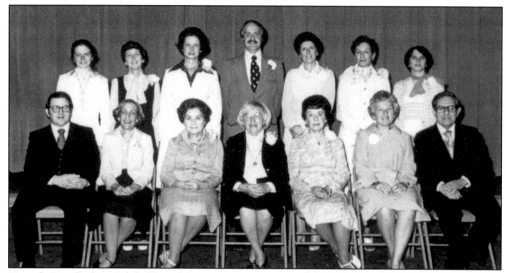

Temple Israel's first Adult B'not Mitzva ceremony was celebrated at Friday evening services on April 22, 1974. In preparation, they had studied Hebrew for two years and had participated in Friday evening services and Temple projects. Pictured from left to right are: (seated) Assistant Rabbi Stephen Barack, Selma Cooper, Dorothy Gilbert, Raleigh Liebenberg, Fannie Cohen, Edith Lange, and Rabbi Max Shapiro; (standing) Natalie Westreich, Donna Apple, Evelyn Pius, Education Director Sidney Weisberg, Linda Saeks, Lynne Brickman, and Francine Harris. (Courtesy of Temple Israel.)

Temple Sisterhood members work long hours serving their congregation and their community. They staff Temple's Gift Shop and raise funds at their annual Garage Sale for camp scholarships, the choir, library, Religious School Seders, Friday night Oneg Shabbats, and much more. Past presidents in 1999 included, from left to right: (front row) Rosalind Jaffee, Marge Graceman Kline, Merle Rosenberg, Dory Rose, and Susie Selcer; (back row) Mary Newman, Sherrill Borkon, Myrna Abrams, Mary Strauss, Lois Rose, Charlotte Klein, Marge Mandel, and Roberta Kravitz. (Courtesy of Temple Israel.)

In the early days of Temple Israel, Sisterhood events included this 1939 "Celebration of America." Mrs. Sid Margolies held the torch of liberty, and other Sisterhood members in the photo include Mrs. Moe Shapiro, Mrs. Sam Weisman, Mrs. Arthur Segal, Ruth Litin and Jean Minter. (Courtesy of Jean Minter.)

Junior Congregation was organized by Rabbi Minda in 1926 to conduct Saturday morning religious services. It quickly grew into a full-fledged service and social group where high school and college-age sons and daughters of Temple members vied for leadership roles, and often met and courted their future spouses. In 1952 it became the Temple Youth Group, and now most of its members were students or graduates of Temple's Religious School. They wore costumes for Purim and sometimes performed for the congregation, and sponsored an alternative Rosh Hashonah and Yom Kippur "Creative Service" in Minda Hall. This 1938 Purim photo includes Paula Liebenberg, Nonie Levy, Judith Glantz and her sister, Robert Rees, Jimmy Ehrlich, Paul Friedman, Nancy Rigler, Connie Altman, Bert Gross, Roland Minda, Jean Minter, and Betty Greenberg. (Courtesy of Jean Minter and Roland Minda.)

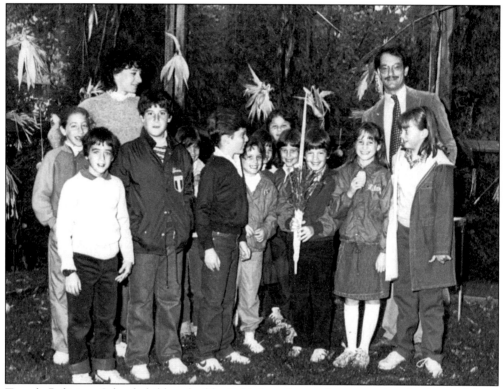

Temple Religious School children build a Sukkah each year in preparation for the week-long harvest festival celebrated in mid-October. Assistant Rabbi Daniel Zemel blessed the Sukkah they built in 1981. (Courtesy of Temple Israel.)

In 1988 Temple Israel's Mitzvah Corps—teenagers who dedicate many hours to helping the community—built this Sukkah during a weekend retreat. (Courtesy of Temple Israel.)

Temple Israel day care teachers are so creative that their program is one of the most sought-after in Minneapolis, with a long waiting list. Jayne White and her colleagues planned this educational "special event"—an indoor Sukkot "camping experience." (Courtesy of Temple Israel.)

Temple Israel youth created a Mitzvah Corps for community service, which included bringing Thanksgiving food baskets to needy families. Gifts of food members brought to services on Sukkot as donations to the Oak Park Children's Home, Shrine Hospital, St. Joseph's Home for Children, the Jewish Family Service, and other organizations were packed by Mitzvah Corps members. Pictured from left to right are Jane Cohen, Robert Hunegs, Cathy Tilsen, Mark Bernstein, Sanford Cohen, and Barbara Fink. (Courtesy of *Minneapolis Star Tribune* and Temple Israel.)

To help pay off their building's mortgage, Temple Sisterhood raised $25,000 in five years at Rigadoo, named after a Scottish folk dance. They sold raffle tickets, built and decorated booths, cooked food for the lunch counter, and solicited prizes ranging from kosher salami to a gift certificate from M. L. Rothschild men's store, with a new automobile as grand prize, and people from all over Minneapolis came to try their luck. Auctioning food baskets at Rigadoo in 1934 were Mrs. James Greenberg, I.S. Joseph and Mrs. Alvin Cohn. (Courtesy of Temple Israel.)

The first Temple "Big Show" fundraiser was staged in 1958. Show-stopping numbers included a duet by Rabbi Minda and his wife, Frances, a solo by Rabbi Max Shapiro, and a comedy routine starring Joseph Lipkin, Gert Glass and Marvin Borman. In 1989 the Big Show chorus line featured, from left to right, Micki Kronick, Margie Alpert, Jan Arnold, Lisa Segal, Maxine Steinberg, Carolyn Latz, Penny Zeissman, and Gail Lehrman. (Courtesy of Temple Israel.)

CONSTITUTION AND BY-LAWS

OF

Associated Jewish Charities ot Minneapolis

Article I. Name.

The name of this corporation shall be Associated Jewish Charities of Minneapolis.

Article II. Object.

The purpose of this corporation shall be as defined in the Articles of Incorporation.

Article III. Membership.

1. Any person who shall pay at least Ten ($10) Dollars per year to the corporation shall be a member thereof for the fiscal year for which such payment is made with a right to vote at all regular and special meetings of the members of said Association.

2. Contributions shall be payable in advance, either annually or in semi-annual or quarterly installments.

3. Six months' delinquency is cessation of membership.

4. The following organizations and activities shall be beneficiaries of the association:

1. Hebrew Ladies' Benevolent Society.
2. Sisters of Peace.
3. The Jewish Free Dispensary.
4. The Jewish Loan Society.
5. The B'nai B'rith Free Employment Bureau.
6. The Sheltering Home.
7. Jewish Orphan Asylum, Cleveland, Ohio.
8. The National Jewish Hospital for Consumptives, Denver, Colorado.
9. Jewish Consumptive Relief Society, Denver, Colorado.

When Associated Jewish Charities of Minneapolis began in 1877, one of its first members was the Hebrew Ladies Benevolent Society, now Temple Sisterhood. (Courtesy of Jewish Family and Children's Service.)

Jewish Social Service Opens First Annual Campaign for World Fund

FEDERATION HERE TO RAISE $65,000; BANQUET TONIGHT

'One Campaign for All Needs' Is Slogan of Federation

With the slogan, "One campaign for all needs," the first annual campaign of the Minneapolis Federation of Jewish Social Service will open Sunday night with a banquet at Hotel Nicollet. The federation seeks to raise $65,000 for conference among 44 local, national, European and Palestinian organizations.

This year's campaign finds, for the first time in the history of Minneapolis Jewry, a united front for all Jewish causes the world over. Reformed Judaism, conservative and orthodox, are enthusiastically participating in this campaign.

Talmud Torah Gets Share

More than 40 per cent of the $65,000 will go to local institutions. The largest recipient locally, will be the Minneapolis' Talmud Torah. The Talmud Torah, with four branches, has 1,000 students attending its various departments.

According to Dr. George J. Gordon, educational director, the Talmud Torah has already graduated 450 students from its various courses.

The next largest agency participating in the fund is the Allied Campaign, which includes the United Palestine Appeal, an outstanding factor in the rebuilding of the new Palestine. The work of this Palestinian institution is regarded as of outstanding importance to Jewry the world over.

Other institutions sharing in the local fund are the National Jewish Hospital of Denver, for consumptives; the Jewish Consumptive Hospital of Los Angeles, the Levi N. Memorial Hospital Hot Springs; the Ex-Patients Tubercular Home of Denver; Jewish Consumptive Relief Society of Denver; Hebrew Union College, Cincinnati; Hebrew Theological School, Chicago; Training School for Jewish Social Workers, New York; Jewish Theological Seminary, New York; Rabbi Isaac Elchanan's Seminary New York; and the National Farm School, Pennsylvania.

Savings Seen in Drive

According to Arthur Brin, chairman of the local campaign, the drive will bring a savings of more than $20,000 to the Minneapolis Jewish Community for the cost of collecting funds.

Members assisting Mr. Brin in directing the campaign are Harold R. Kaufmann, vice chairman; S. Joseph, treasurer; and Miss Anna F. Skolsky, secretary.

Actual solicitation of funds is under the direction of Albert H. Heller. Joseph H. Schanfeld has charge of the Flying Squadron, a team responsible for the success of solicitation.

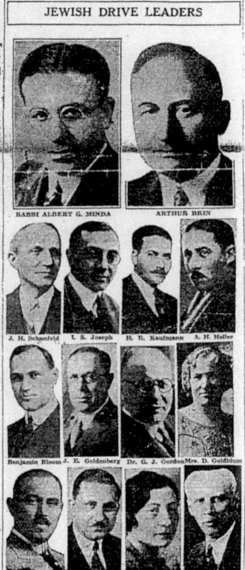

JEWISH DRIVE LEADERS

RABBI ALBERT G. MINDA — ARTHUR BRIN

J. H. Schanfeld — L. S. Joseph — H. R. Kaufmann — A. H. Heller

Benjamin Bloom — J. E. Goldenberg — Dr. G. J. Gordon — Mrs. D. Goldblum

I. H. Boblisbek — L. S. Eintracht — Anna Skolsky — Dr. M. Lemovile

Many Jews believe that "religion and community service go hand in hand; they're the rent you pay for the space you take up on this earth." When the Depression became a harsh reality in 1930, Rabbi Minda and Temple members, with Arthur Brin as campaign chair, lead the way in organizing the Minneapolis Federation of Jewish Social Service. In their first "One Campaign for All Needs" they raised money for 44 Jewish causes. (Courtesy of Frances Minda.)

The officers of the 1936 Campaign of The American Jewish Joint Distribution Committee extend their heartfelt appreciation to

Amos S. Deinard

for cooperation and leadership in the Campaign for aid to the distressed Jews of Germany and of Eastern Europe. Your name is hereby added to the honorable record of our distinguished co-workers in the great humanitarian program of bringing reconstructive service, relief and hope to the Jewish people in many countries overseas.

December 31, 1936

Chairman

Co-Chairman

Co-Chairman

Co-Chairman

Treasurer

Associate Treasurer

Vice-Chairman

Vice-Chairman

Vice-Chairman

Secretary

Comptroller

Campaign Director

As Adolf Hitler embarked on his plan to destroy the Jewish people, attorney Amos Deinard, the son of Shaarai Tov's beloved Rabbi Samuel Deinard, continued his father's dedication to community service. (Courtesy of Temple Israel.)

BRAILLE CLASS MEETS

Shaarai Tov women organized the Hebrew Ladies Benevolent Society to care for the sick, prepare the dead for burial, and help new immigrants and the Jewish poor. By the 1930s, as Temple Sisterhood, they sponsored ice cream socials, card parties, dances, sewing bees, dinners, lectures, and other events to raise money for their synagogue. They also offered classes in art, cooking, contemporary dance, basic Judaism and other subjects, and were involved in interfaith activities, education, and Religious School Seders. They sang in the choir, stocked and staffed the library, cooked dinner for the congregation's annual meeting, and arranged the Oneg Shabbats following Friday night services. In 1942 the Red Cross was looking for a church group to transcribe books into braille for the blind, and Mmes. Joseph Seltzer, Benjamin Solomon, Joseph Bonoff and H. Z. Mendow used Sisterhood funds to organize Temple's Braille Transcribing Project. After an arduous six to ten months in training, they provided graphs and maps for the Library of Congress and every textbook a blind student would need from elementary school through college to a Ph.D. degree. (Courtesy of *Minneapolis Star*.)

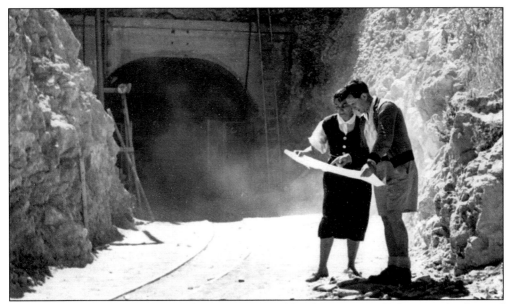

On a 19-day tour of Israel in April, 1953, sponsored by the Women's Delegation for State of Israel Bonds, Florence Kunian Schoff spent a day with a housewife in Jerusalem, visited an Arab school in Nazareth, and viewed high-tech works-in-progress, including this railway construction project and a giant new pumping station designed to supply the Galilee with much-needed water. (Courtesy of *American Jewish World*.)

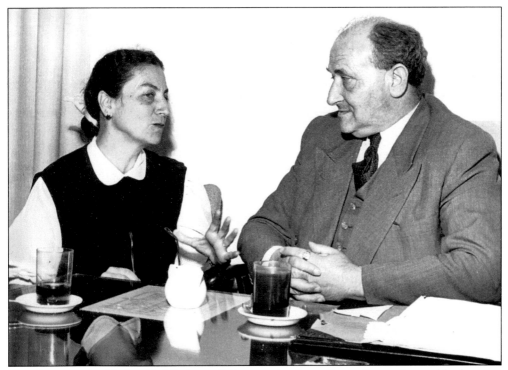

She also visited with Israel's Minister of Communications, Peretz Bernstein, and had a two-hour conference with Prime Minister David Ben Gurion. (Courtesy of *American Jewish World*.)

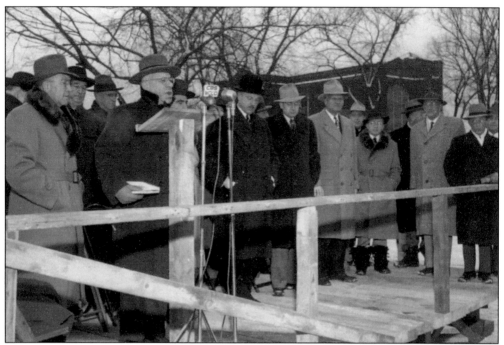

Rabbi Minda participated in the groundbreaking ceremony for Mt. Sinai Hospital in 1948. When it opened in 1951, it also granted admitting privileges to non-Jewish physicians, which lead the way for other hospitals in Minneapolis to change their anti-Semitic policies and permit Jewish doctors to join their staff and bring patients to their facilities. (Courtesy of Temple Israel.)

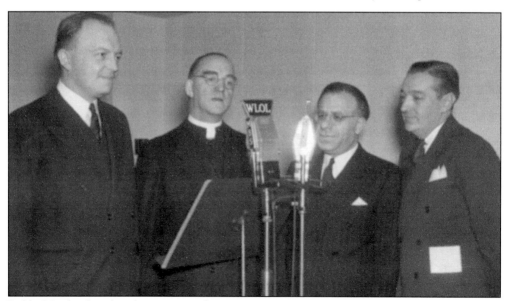

Rabbi Minda also played an active role in encouraging Minnesotans of different faiths to join the National Conference of Christians and Jews (NCCJ). He joined with, from left to right, Governor Harold Stassen, Father Flanagan of Boys' Town, and Pastor Paul Dobson to broadcast their program's agenda, and the need to work together, on Twin Cities radio station WLOL. (Courtesy of Temple Israel.)

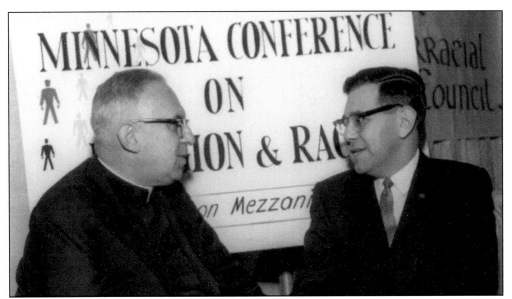

In 1964 Rabbi Max Shapiro and Bishop Leonard P. Cowley co-chaired the first Minnesota Conference on Race and Religion. (Courtesy of Temple Israel.)

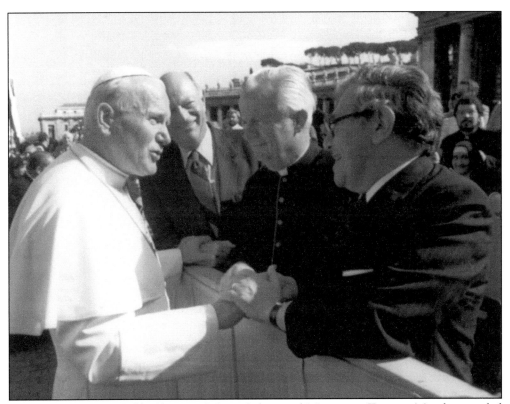

In November, 1983, Rabbi Shapiro, Sidney Cohen and Monsignor Terence Murphy traveled to Rome to meet with Pope John Paul II for an international conference on interfaith relations. (Courtesy of Temple Israel.)

In 1993 Dr. Arthur Zannoni presented Temple Israel with an Inter-Religious Award for their work on interfaith issues in the larger community. Pictured from left to right are: (seated) Sidney Cohen, Rabbi Max Shapiro, Dr. Zannoni, Rabbi Joseph Edelheit, and June Barron; (standing) Sherrill Borkon, Cathy and Bonnie Sussman, Rabbis Marcia Zimmerman and Joe Black, Cantor Barry Abelson, Steven Gray, Lucky and Leonard Levy, and Harlan Jacobs. (Courtesy of Temple Israel.)

One of the "good works" projects organized by Temple's Social Action Committee was a clothing drive to aid black American families in poverty-stricken areas of the Mississippi Delta, after they were featured in an article in Look magazine. Temple Youth Group members helped package the clothing, which was shipped to three organizations in Greenville, Mississippi—Delta Ministry, the high school PTA, and Sacred Heart Catholic Church—that distributed the clothing to needy families. (Courtesy of *Minneapolis Spokesman*.)

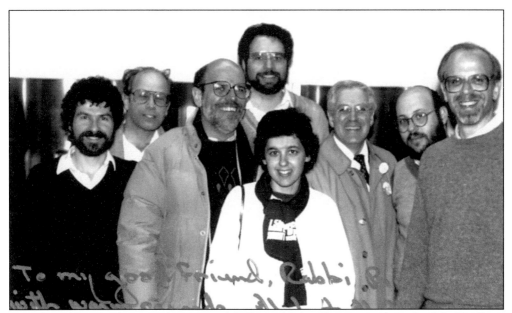

Temple Rabbis Stephen Pinsky, Howard Jaffe, and Max Shapiro, and St. Paul Rabbi Ilene Melamed, director of Temple's Religious School, flew to Washington, D.C. on December 6, 1987, the eve of Soviet leader Mikhail Gorbachev's visit to the United States. They joined some 200,000 protesters who marched down Constitution Avenue to Capitol Hill to send the message that Jewish emigration from the Soviet Union should figure prominently in President Reagan's summit meeting with Gorbachev. (Courtesy of *New York Times* and Temple Israel.)

Sen. Hubert Humphrey's son, Hubert Humphrey, Jr., joined the Minneapolis delegation, carrying a "Let Them Go To Israel!" sign. (Courtesy of Temple Israel.)

Temple Israel and five nearby churches organized the Neighborhood Involvement Program in 1972 to provide low-income families with counseling, tutoring, medical and dental care, job training, a "clothes closet" and food shelf, and other services. Early part-time volunteers at the clinic included 20 doctors and 80 nurses. (Courtesy of Temple Israel.)

Temple's Social Justice Committee was involved in civil rights, food shelves, resettlement of Hmong and Vietnamese refugees and Soviet Jewish newcomers, and other causes. Committee chair Max Fallek (below, left), shown here with Rabbis Max Shapiro, Stephen Barack, and Daniel Zemel, arranged to buy this house on Fremont Avenue South to house incoming Vietnamese families until they could afford to live independently. (Courtesy of Temple Israel.)

Rabbis Shapiro and Zemel visited with this grateful Vietnamese family. (Courtesy of Temple Israel.)

Three

BET SHALOM
A GROWING FAMILY OF FRIENDS

Bet Shalom, the "House of Peace," became a reality on May 17, 1981, after five months of research by 70 Reform Jews who wanted a new, smaller, more intimate Reform congregation in Minneapolis. They elected a Board of Trustees and set two short-term goals: to be fully functioning by September, so they could have High Holiday services, and to establish a religious school for their children, from kindergarten through ninth grade. They also set a long-term goal: to find a Rabbi who would want to be part of a fledgling congregation.

All of their goals were met. With 32 families as members, they signed an agreement with the Jewish Community Center, permitting them to hold Shabbat services there and to organize education programs for their children. Fifty children attended their first religious school classes at the JCC on September 12, 1981, and Bet Shalom's first Rosh Hashonah and Yom Kippur services, also at the JCC, were lead by visiting Rabbis from Washington D.C. and Chicago. And then, in what one member called "the perfect beginning to the New Year and new congregation," Rabbi Norman Cohen agreed to leave Rockdale Temple in Cincinnati to become Bet Shalom's Rabbi.

In the Spring of 1982 they conducted their first three B'nai Mitzvot at the JCC, where they continued to worship and have their religious school classes. And then, in July, 1985, with a membership already numbering 200 families, they purchased the Old Apostolic Lutheran Church building at 201 Ninth Avenue North, in Hopkins. They were farther west than any other Minneapolis Jewish congregation, and they continue to be so in their new synagogue on Orchard Road in Minnetonka. Although it had snowed the night before, they marched the four miles to their newly completed building on April 29, 2002, with buses for people who couldn't walk. Members took turns blowing the shofar as they walked, and they stopped at three neighborhood churches en route, where the church choirs came out to sing to them. And when they arrived at their new building, they sang and danced as Rabbi Cohen put their Torahs in their new ark.

Bet Shalom is an architectural wonder designed by architects Milo Thompson and Gary Milne-Rojek, members of Bentz Thompson Reitow. It has walls that move, so that the sanctuary, designed as an "intimate space" for 500, can accommodate the 1,300 people who come to worship on the High Holidays. More than 800 families are members of Bet Shalom today, and in addition to Religious School and Hebrew classes, they also attend Adult Education classes that feature guest lecturers on topics that range from "Jewish Spirituality" to current issues, like "Why Elections Are Being Held Early in Israel."

Preamble to The Bylaws of Bet Shalom Congregation

It will be a place that will be a
family of friends.
It will be a place where you will
feel a sense of belonging, whether
you are an adult or a child,
young or old.

It will be a place where adults and
children will learn together.

It will be a place where nobody will
be lost in the shuffle of numbers.
It will be a place where our children
will learn to know and understand
other lifestyles and values as well
as they understand their own.

It will be a place of involvement --
from the rituals on the pulpit
to participation in services
to the dishes in the kitchen.

It will be a place where quality is
stressed.
It will be a place where we laugh, cry,
love and grieve as we practice
our Judaism together.

Founding members of Bet Shalom were John and Ann Lonstein, Yale and Diane Dolginow, Rick and Susie Nemer, and Jack and Cindy Mayeron. Ann Lonstein wrote the "Preamble to the Bylaws of Bet Shalom Congregation." (Courtesy of Bet Shalom.)

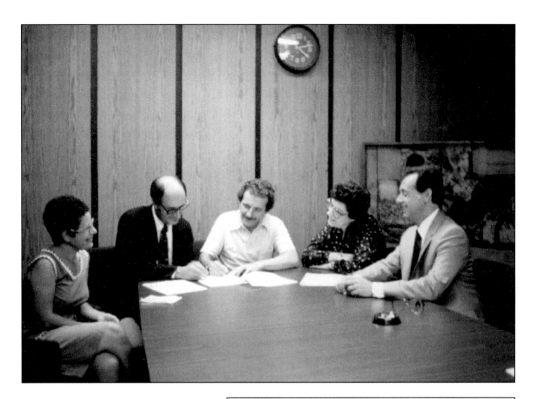

On May 17, 1981, Director Bill Budd signed an agreement permitting Bet Shalom to use the Minneapolis Jewish Community Center as their Worship Center until they could afford a synagogue. Their first Board of Trustees included president John Lonstein, vice presidents Jack Mayeron and Howard Katz, secretary Barbara Hanovich, treasurer Gene Fabes, and board members Yale Dolginow, Leonard Leder, Ann Lonstein, Steve Machov, Susan Muscoplat, Frederick Nemer, and Ben Smith. (Courtesy of Bet Shalom.)

Bet Shalom Congregation cordially invites you to attend the Installation of our Rabbi Norman M. Cohen at Shabbat Services Friday, October 29, 1982 8:00 in the evening at the Jewish Community Center of Minneapolis

Oneg Shabbat following services

Four months later, in September, 1981, Rabbi Norman Cohen came from Cincinnati, Ohio, to serve as Bet Shalom's first Rabbi. (Courtesy of Bet Shalom.)

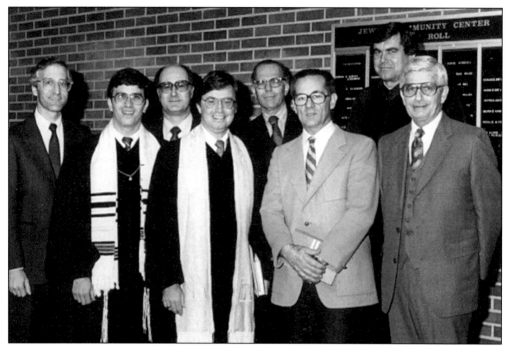

Honored guests at Rabbi Cohen's installation on Friday, October 29, 1981, were, from left to right, Rabbi Leigh Lerner, Rabbi Cohen, Bet Shalom president John Lonstein, Rabbi Howard Simon (Rabbi Cohen's colleague in Cincinnati), JCRC-ADL Director Mort Ryweck, JCC President Herman Markowitz, Rev. Bob MacLennan of Colonial Church of Edina (who coordinated interfaith dialogue with Rabbi Cohen), and Edward Sherman. (Courtesy of Bet Shalom.)

Bet Shalom members entertained at the dinner following the installation service. Pictured from left to right are Linda Valfer (at far left edge), Mort Shapiro, Howard Katz, Rick Nemer, Carol and Bob Mayeron, Cindy and Jack Mayeron, and Diane and Yale Dolginow. (Courtesy of Bet Shalom.)

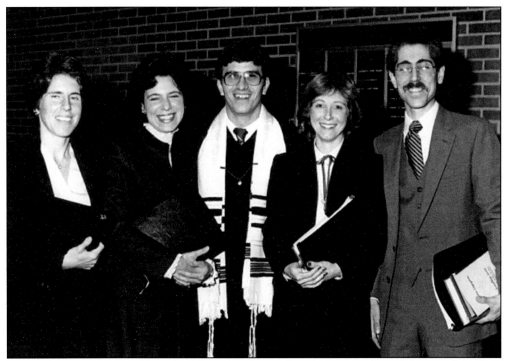

Joining Rabbi Cohen at Friday night services at the JCC were, from left to right, choir members Beth Yelensky, Claudia Schnitker, Carol Mayeron, and David Pogroff. (Courtesy of Bet Shalom.)

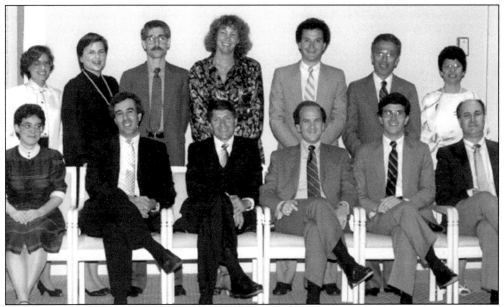

The 1984-85 Board of Trustees at Bet Shalom included, from left to right: (seated) Joan Charnas, Howard Katz, Jack Mayeron, Yale Dolginow, Rabbi Cohen, and John Lonstein; (standing) Janice Feinberg, Robin Abrams, David Pogroff, Ceil Gordon, Steve Machov, Len Leder, and Esther Fabes. (Courtesy of Bet Shalom.)

The Dedication November 15-17, 1985

Bet Shalom Congregation
201 Ninth Avenue North
Hopkins, Minnesota

On November 15, 1985, with their rapidly-growing congregation now totaling 200 families, Bet Shalom moved from the JCC to their newly purchased building in Hopkins, formerly a Lutheran church. (Courtesy of Bet Shalom.)

Rabbi Cohen has written a series of "how-to" booklets to help his congregants plan family events. (Courtesy of Bet Shalom.)

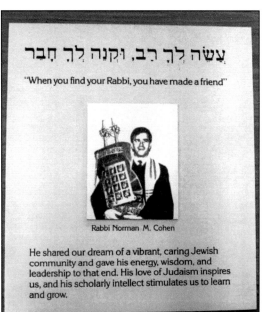

This plaque signifies Bet Shalom's respect and love for their rabbi. (Courtesy of Bet Shalom.)

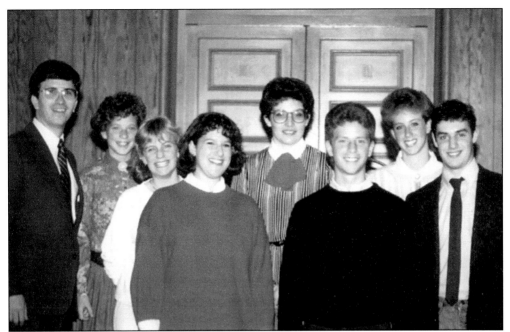

Confirmation for 15-year-olds is now a tradition at Bet Shalom. This Confirmation class, taught by Elaine Robashkin, included Jessica Nemer, Annie Hanovich, Debbie Dolginow, Bradley Nemer, Debbie Friedman, and Ryan Litman. (Courtesy of Bet Shalom.)

During the 1983–84 school year, Bet Shalom's Religious School, founded by Ann Lonstein, included faculty and staff members Vivian Mann, Lisa Dolginow, Barbara Luskin, Susie Nemer, Linda Shapiro, Joan Charness, Mara Litman, Marna Reed, and Barb Abramson. (Courtesy of Bet Shalom.)

Creative Religious School teachers like Barbara Luskin teach students how to make exhibits for Sukkot, Chanukah, and other holidays. (Courtesy of Bet Shalom.)

(*left*) Rabbi Ilene Melamed, who grew up in St. Paul, served as Bet Shalom's Education Director from 1984–1990. Today there are more than 500 children enrolled in their Religious School. (Courtesy of Bet Shalom.)
(*right*) Religious School students are taught that on Simchat Torah they are meant to unroll the Torah and roll it back to its beginning. (Courtesy of Bet Shalom.)

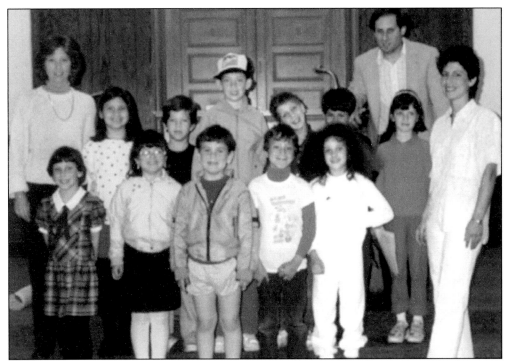

Kindergarten and first-grade students listened intently to an explanation of the Purim celebration, c. 1983–84. (Courtesy of Bet Shalom.)

Many parents volunteer to teach at Religious School, which now has two sets of classes on Sunday mornings, plus after-school classes, and a Wednesday evening class for students in grades 7–10. (Courtesy of Bet Shalom.)

Bet Shalom's first Confirmation Class, in May, 1983, included, from left to right: (seated) Debbie Valfer, Alan Lonstein, and Philip Smith. Lonstein was Bet Shalom's first Youth Group President, and now serves as Assistant Rabbi at Temple of Aaron in St. Paul; (standing) Heather Lehman, Lisa Dolginow, Jody Dockman, Kathy Fabes, Nicky Smith, and Mara Litman. (Courtesy of Bet Shalom.)

Bet Shalom's Youth Group get-together in 1988 was "fun time" for Jason Lonstein, Keri Goldstein, Adam Bass, and Dan Gelt. (Courtesy of Bet Shalom.)

Rabbis and faculty party with Bet Shalom's Religious School students when it's time to celebrate Purim. The children wrote their own script for their 2001 Purim show. (Courtesy of Bet Shalom.)

Dressed in costumes for their Purim play were Rabbi Cohen as Batman, Assistant Rabbi Erin Polansky as Robin, cantoral intern Sarah Lipsett-Allison, and education director Helen Winoker. (Courtesy of Bet Shalom.)

And now it's time for Bet Shalom's "next generation" to celebrate in the congregation's outdoor Sukkah. Pictured from left to right are Steve Mayeron, Leon Lonstein, and Jamie Dolginow with their families and friends, David and Jack Mayeron, Yale Dolginow, Leonard Leder, and Joanne and Bruce Gruen. (Courtesy of Bet Shalom.)

THANKSGIVING INTERFAITH SERVICE
WEDNESDAY, NOVEMBER 27, 7:30 P.M
AT BET SHALOM CONGREGATION

Join us again this year for our annual Thanksgiving celebration with our Interfaith partners, Hopkins United Methodist Church, Mizpah United Church of Christ, and St. Paul's Lutheran Church.

Please don't miss this beautiful service of sharing prayers of Thanksgiving with our friends.

Bet Shalom is also involved with the larger community in events like their annual Thanksgiving Interfaith celebration with three neighboring churches—Mizpah United Church of Christ, Hopkins United Methodist Church, and St. Paul's Lutheran Church. (Courtesy of Bet Shalom.)

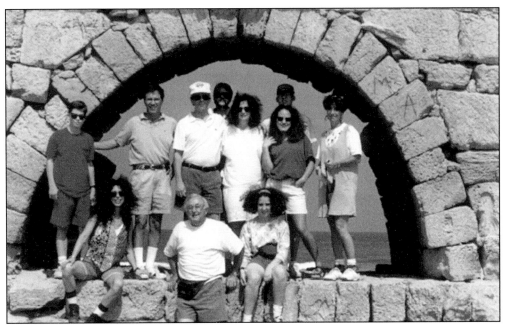

Bet Shalom members visited historic Caesarea on a 1992 trip to Israel. Pictured from left to right are: (front row) Annette Modell, Sam Schenfeld, and Alexis Mansfield; (back row) Aaron Winter, Rabbi Cohen, Seymour and Susan Mansfield, Marnee Tyler, Justin Mansfield, and Michelle Tyler. (Courtesy of Bet Shalom.)

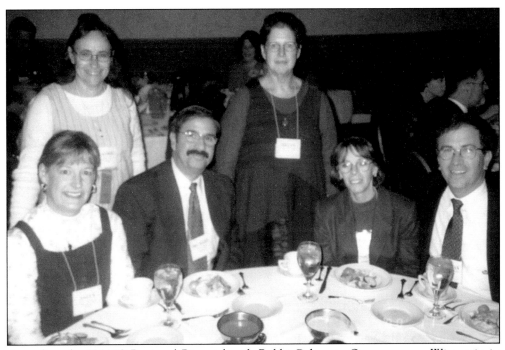

Attending the UAHC Regional Biennial with Rabbi Cohen in Oconomowoc, Wisconsin in 2002 were Bet Shalom members, from left to right, Sally Bressler, Laurie Levin, Michael Pysno, Helen Winoker, and Sara Jay. (Courtesy of Bet Shalom.)

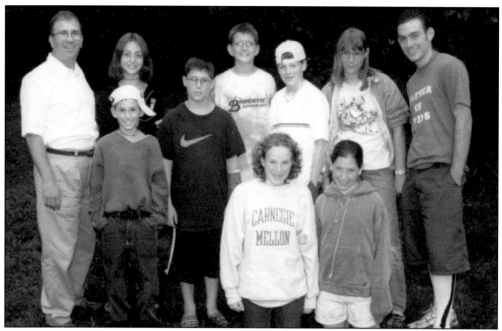

Rabbi Cohen teaches two-week sessions during the summer at Camp OSRUI—Olin Sang Ruby Union Institute—a Jewish-oriented camp in Oconomowoc, Wisconsin, that was founded by the Olin, Sang, and Ruby families. Campers in 1999 included, from left to right: (seated in front) Jami Kramer and Becky Besasie; (standing) Iain Crosby, Molly Dworsky, Cameron Crosby, Matt Erickson, Aaron Wade, Leah Bressler, and Harlan Luxenberg. (Courtesy of Bet Shalom.)

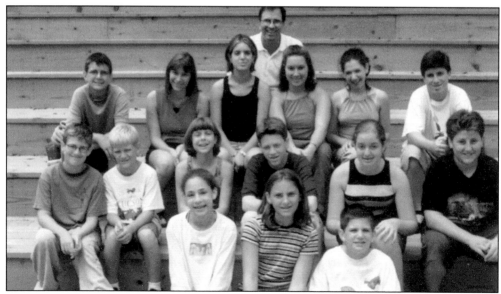

Many OSRUI campers return year after year. Pictured from left to right are: (front row) Hannah Cutts, Jori Liefschultz, and Lucas Martin; (middle row) Zachary Christensen, Bryan Erickson, Natalie Nidetz, Aaron Wade, Sophie Klein, and Jake Liefschultz; (back row) Matt Erickson, Leah Bressler, a camp guest, Molly Mitchell, Becky Besasie, and Adam Simpson. (Courtesy of Bet Shalom.)

Beresheet . . .

Members planning their new synagogue building included, from left to right, Sally Bressler, Susie Mansfield, Sam Stern, Tom Silver, Dick McNeil, Michael Pysno, Yale Dolginow, Helen Winoker, Steve Carples, Rabbi Cohen, and Andrea Blumberg. (Courtesy of Bet Shalom.)

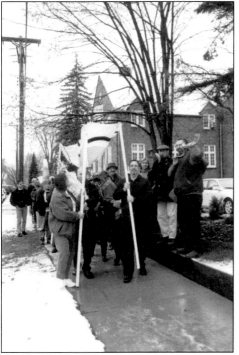

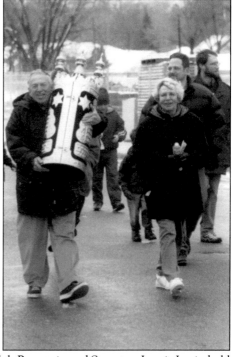

On the march to their new synagogue, Treasurer Ralph Bernstein and Secretary Laurie Levin held the front end of the canopy, John Lonstein carried the Torah, and Vice President Dick McNeil and other members blew the shofar and sang along the way. Marvin Greenblat also carried a Torah, accompanied by his wife, Doreen, and Bob and Lara Rubinyi.(Courtesy of Bet Shalom.)

Rabbi Cohen and Assistant Rabbi Erin Polansky celebrated with Marla Rusewald at her Confirmation, the first in their new synagogue. (Courtesy of Bet Shalom.)

CZECHOSLOVAKIAN TORAH SCROLL #3
FROM THE TOWN OF KLATOVY
ON PERMANENT LOAN TO
BET SHALOM CONGREGATION

This Torah scroll, like all others, contains the Five Books of Moses, telling the story of our people's origins. This particular Torah scroll also witnessed another story. It saw the Nazis come to Klatovy and destroy the synagogue which housed it. It saw the Nazis deport the good people who read from it and blessed it. It was taken by the Nazis and thrown into a pile of 1,564 Torah scrolls that were intended to be part of a museum to an extinct people, a research and propaganda institute that would justify to the world what the Nazis did as a "Final Solution to the Jewish Question."

After the war, the communities to which these Torah scrolls belonged no longer existed. The Allies sent the scrolls to London, where the Westminster Synagogue distributed them to Jewish congregations throughout the world as a symbol that Judaism continues to exist and flourish long after the Nazis sought to destroy it.

Today, this Torah scroll serves as a different kind of witness. It sees the vibrancy of our congregation's life. It welcomes us as we enter for study, prayer, and community activities. It hears the sounds of worship, celebrates the baby namings and weddings and listens to our voices saying Kaddish.

When we look at the scroll, as we enter and leave our sanctuary, we see not just the pain of the past, but the glory of the present and the promise of the future. The mirror in this case reflects ourselves, reminding us of our personal responsibility as the bearers of the Jewish tradition.

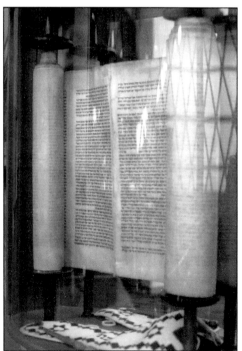

This Czechoslovakian Torah Scroll, on display at the entrance to their sanctuary, is on permanent loan to Bet Shalom. It's one of 1,564 Torah scrolls the Nazis had saved for the "Museum To An Extinct People" they were planning to build after they won World War II. (Courtesy of Bet Shalom.)

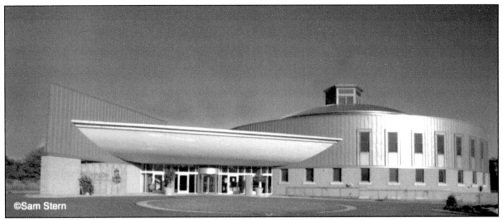

Bet Shalom's new synagogue building in Minnetonka was designed by architects Milo Thompson and Gary Milne-Rojek. (Photo by Sam Stern.)

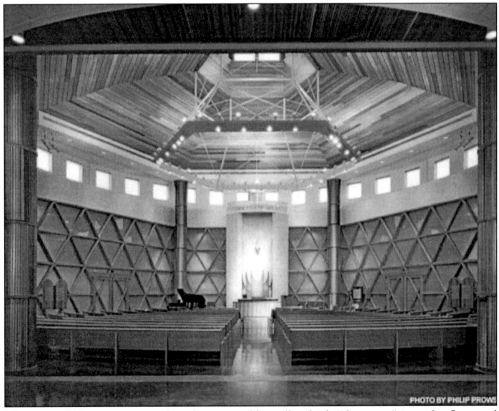

Their new 500-seat sanctuary has three movable walls which "disappear" into the floor and ceiling, allowing seating to extend into the social hall in order to accommodate the more than 1,300 people who attend services on Rosh Hashonah and Yom Kippur. (Photo by Philip Prowse, courtesy of Bet Shalom.)

Bet Shalom members also involve themselves in community service, and spent a "Mitzvah Day" in 2002 as volunteers for Save Cedar Lake Park. They were searching out and removing an invasive weed called buckthorn, a shrub that some people continue to plant despite the fact that it was banned in the 1930s by Minnesota's Department of Natural Resources because it spreads rapidly and kills all the plants nearby. Working near the pedestrian bridge by the Minneapolis JCC were Wendy and Bob Lazear and their son Samuel, Rabbi Cohen, and Zelia Goldberg. (Courtesy of *Cedar Lake Park Update*.)

Four

Shir Tikvah
At Home in the City

Temple Israel was preparing to celebrate its 110th anniversary, and Bet Shalom its 10th, when six people met at a St. Paul restaurant in February, 1988 to discuss their vision of a new synagogue "in the spirit of liberal Judaism," a congregation that would "welcome and encourage individuals and families of varying Jewish lifestyles."

More than 100 people attended their first congregational meeting several weeks later, and they held their first Shabbat service in May, 1988. In August they chose Stacy Offner, who had come to Mount Zion Temple in St. Paul several years earlier as Minnesota's first woman Rabbi, to lead their new congregation, which they had decided to call Shir Tikvah, which in English means "Song of Hope."

Shir Tikvah began with only 40 households enrolled as members, but it continued to grow, and in 1994 they purchased the Unitarian First Universalist Church at 50th and Girard Avenue South. The building was for sale because the Unitarians needed a larger house of worship, and had purchased Adath Jeshurun's synagogue at 34th and Dupont Avenue South when Adath moved to their new building in St. Louis Park.

Hundreds of members and guests came to Shir Tikvah on November 15, 2002 for "Chanukah Sefer HaTorah," a special dedication service for their new Torah, which had come from Congregation B'nai Judah in Whiting, Indiana. The service included music by the congregation's Music Director, David Harris of Voices of Sepharad, and featured "Chain of Continuity," written by Ed Janoff and Sima Rabinowitz and sung by Sima Rabinowitz, Helen Kivnick, Ray Levi, Judy Hollander, and Sam Kanson-Benanav, with Gary Gardner playing the concertina and the congregation chiming in after each solo with "We are the people of the Book, and our Book is the Torah." And then, when it was time to return the Torah to the Ark, the congregation joined in with "Every Letter Sings," also written for the occasion by Sima Rabinowitz, Helen Kivnick, and Gary Gardner, and the service ended with the Adult Choir, conducted by Susan Wood, singing congregant Bonia Shur's "Torah Li."

Shir Tikvah today is a family-oriented congregation of more than 330 households, and continues to grow at the rate of about 30 households per year. During the High Holidays the building that was formerly Adath Jeshurun returns to Judaism because Shir Tikvah has maintained a friendly relationship with the Unitarians, and their sanctuary is large enough to seat Shir Tikvah's entire congregation and their guests—attendance that reached 1,200 on Rosh Hashonah in 2003.

Shir Tikvah

A Reform Congregation Serving the Twin Cities

OUR MISSION STATEMENT

We are coming together as a community to provide a place of Jewish worship, learning and assembly, and to engage in various other activities that will promote the spiritual and educational welfare of our members.

Our focus is the building of a caring, inclusive community, in the spirit of liberal Judaism. We are committed to a participatory and democratic process both in congregational governance and in ritual.

We welcome individuals and families of varying Jewish lifestyles. We are particularly sensitive to the need for inclusion of both traditional and nontraditional family structures, and for the development of an appropriately inclusive ritual life that enriches our Jewish experience.

We are fully committed to a policy of nondiscrimination on the basis of gender, marital status, race, age, or sexual orientation, in all aspects of congregational life. This will include, but not be limited to membership, Rabbinic and lay leadership, employment, and ritual involvement.

Our personal philosophies and practices may vary widely among us. However, we are united in a common commitment to Judaism and to furthering our spiritual growth individually and communally. We desire to do this within a liberal Jewish context, and by working together, along with Rabbinic leadership, to develop meaningful Jewish worship.

We recognize that study of Torah is an ongoing life-long process. Development of Jewish identity and knowledge of our traditions will begin with religious and Hebrew education programs for children and continue with appropriate programming for adults. We hope to encourage and support one another as we grow in our studies and apply the wisdom and principles of our heritage in acts of loving kindness and social responsibility.

Shir Tikvah's synagogue at 50th and Girard Avenue South was formerly the home of the Unitarian First Universalist Church. (Photo by Tom Lewin.)

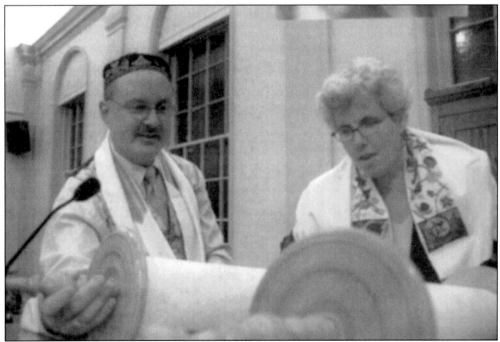

Computer programmer and former psychotherapist and counselor Steve Greenberg travels a great deal on business, but also volunteers as Cantor for Shir Tikvah's Friday night worship services. (Courtesy of *American Jewish World*.)

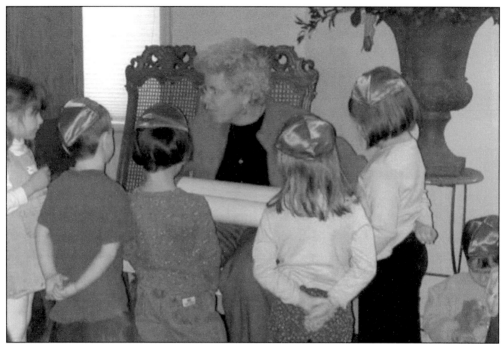

Childhood education has become a special concern at Shir Tikvah as their congregation continues to grow and more Hebrew is included in Reform prayer books. They have their own Hebrew School, and Education Director Penny Schumacher recruits 11th and 12th graders to help teach the younger children as part of their own Jewish education. Rabbi Offner introduces five-year-olds to the Torah Scroll as part of their preparation for Consecration on Simchat Torah. (Courtesy of Shir Tikvah.)

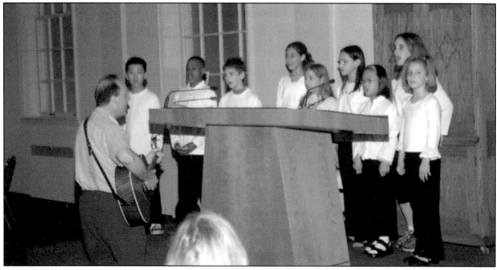

Junior Choir Director Ian Silver accompanies the Children's Choir on his guitar. Pictured from left to right are Alexander Greenhaugh, Darrin Levine, Robbie Seltzer-Schultz, Madeline Shaw, Sharon Abramson, Emily Silber, Sarah Greenhaugh, Erica Seltzer-Schultz, and Mara Brennan-Magidson. (Courtesy of Shir Tikvah.)

Religious School teacher Shayna Berkowitz prepares Shir Tikvah's seventh graders for Confirmation at weekly classes. Students include Becca Kalanser, Sam Schwartz, Ari Resnick, Tobie Abramson, and Abby Addis. (Courtesy of Shir Tikvah.)

Religious School teacher Kathy Nemer encourages her students to think creatively, including making their own tee-shirts. (Courtesy of Shir Tikvah.)

Many Shir Tikvah members attend monthly *Mishpocha* (family) classes with their children and grandchildren. Included in this photo are parents and grandparents Janet Weisberg, Pam Rochlin, Ann Silva, and Scott Strauss. (Courtesy of Shir Tikvah.)

Adult Bar and Bat Mitzvot are a growing tradition in Reform Judaism. Rachel Lipkin, Paula Forman, Ron Giteck, Denise Tennen, and Sue and Patrick Gambill-Reed, members of the class of 2003, studied Torah with Steve Shapiro as their instructor. (Courtesy of Shir Tikvah.)

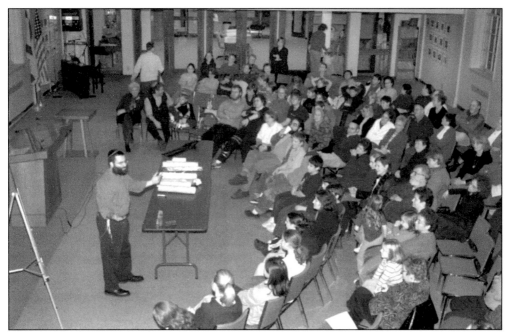

When their home-town congregation in Indiana closed down, Shir Tikvah members Helen Kivnick and Gary Gardner purchased their synagogue's Torahs and donated them to their new synagogue. In keeping with Jewish tradition, Shir Tikvah hired Rabbi Moshe Druin, a nationally-known Torah scholar, to come to Minneapolis to "kosher" their new Torah scrolls. (Courtesy of Shir Tikvah.)

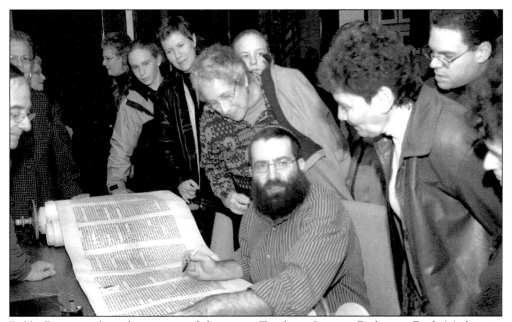

Rabbi Druin explained a section of their new Torah to Sumner Richman, Ruth Markowitz, Nancy Abramson, Verna Lind, Miranda Lippold-Johnson, Lu Lippold, Judy Reisman, Elianah Lippold-Johnson, Virginia Levi, and Jeremy Pierotti. (Courtesy of Shir Tikvah.)

Shir Tikvah children were fascinated by the size and complexity of their Torah scroll. (Courtesy of Shir Tikvah.)

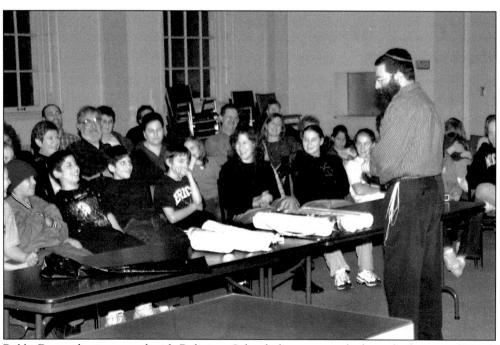

Rabbi Druin also interacted with Religious School classes to teach them the history of Torah writing and repair. (Courtesy of Shir Tikvah.)

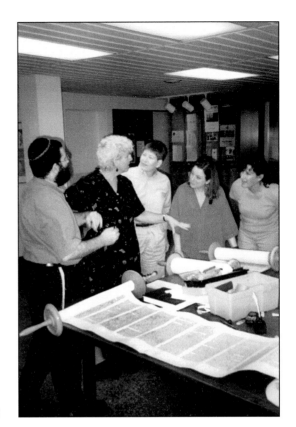

Rabbi Druin and Rabbi Stacy Offner explained details to Musical Director Susan Wood, Religious School teachers Helen Kivnick and Jennifer Lewin, and many other members of the congregation. (Courtesy of Shir Tikvah.)

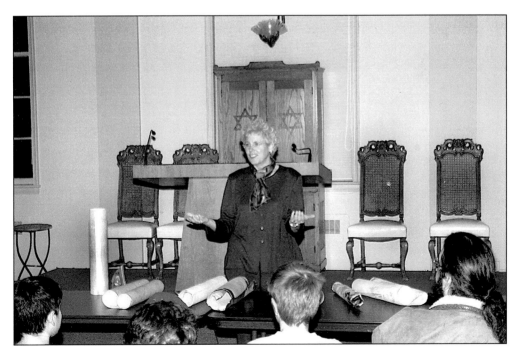

Shir Tikvah's choir, rehearsing with their director, Susan Wood, includes, from left to right: (front row) Sharon Preves, Erica Sachs-White, Barbara Steinberg, Pam Goldman, Lara Friedman-Shedlov, Leslie Cafarelli, and Jane Newman; (back row) Patrick Gambill-Reed, Harvey Zuckman, Phil Oxman, Jim Miller, Morrie Hartman, Dan Friedman-Shedlov, Mark Tempel, and David Harris. (Courtesy of Shir Tikvah.)

Rabbi Offner welcomes congregants and guests like David Kanson-Benanav and Zachary Levinger when they arrive for weekend Torah study and Sunday School. (Courtesy of Shir Tikvah.)

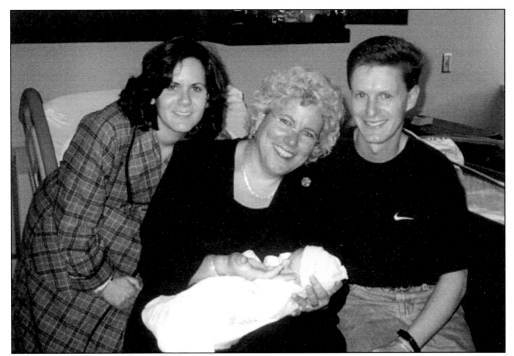

Beckie Skelton (far left) and Shep Harris (far right) brought their new-born daughter, Avital, to Shir Tikvah for a traditional baby-naming ceremony. (Courtesy of Shir Tikvah.)

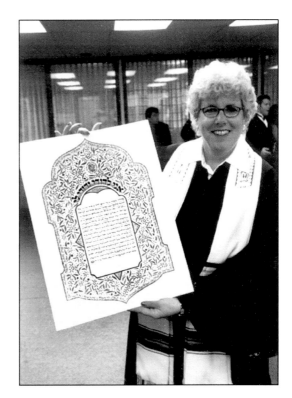

Rabbi Offner presents a Ketubah to couples who are married at her synagogue. This Ketubah celebrated the marriage of Daniel Tennenbaum and Tara Deshpande on April 29, 2001. (Courtesy of Shir Tikvah.)

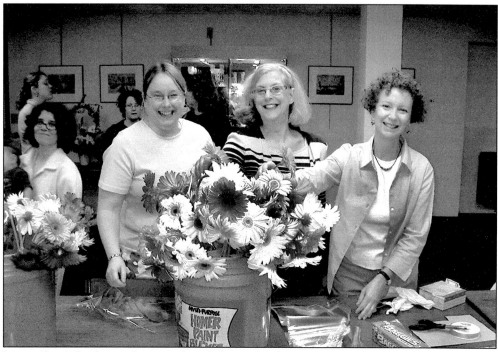

Many Shir Tikvah members purchased flowers at their synagogue for Mothers' Day gifts in 2002. Judy Silver, DuAnne Mednick, Gloria Weinblatt, and Susan Watchman volunteered to work the sale, which was a fundraiser for their Religious School. (Courtesy of Shir Tikvah.)

Liturgy and Latkes

Don't miss the fun at this year's Hanukkah brunch
Saturday, December 7
Service at 10:30 a.m.
Brunch following

It is time once again for Shir Tikvah's Festival of Lights celebration. Seating is limited, so we encourage you to register as soon as possible. Those attending should bring 12 servings of the following, by last name:

A–F: Dessert G–R: Main dish S–Z: Salad/vegetable

Shir Tikvah's Festival of Lights celebration, which includes a Hanukkah brunch, is one of the many congregational events which introduces newcomers to Shir Tikvah and its members. (Courtesy of Shir Tikvah.)

Adult Education Offerings for 5764

Jewish Practice and Belief

An introduction to Judaism based on the cycle of the Jewish year and lifetime. This course focuses on specific holidays and life cycle events, while offering participants an opportunity to wrestle with issues of theological and historical significance. An introduction to Hebrew language forms part of this 10-week survey course. Regular attendance at Shabbat services is strongly recommended as a complement to the class. *This class is required for congregants preparing for a Bar/Bat Mitzvah.*

Instructor: Rabbi Offner

Schedule: 10 weeks, September–December 2003

(See insert in this newsletter)

Hearing Inner Voices: *New this year* Psalms, Prayers, and Meditations

The voice is a deep conduit between body and soul, group and individual, tradition and community. This four-week class will explore how each of us uses his/her voice to connect with the disciplines of Jewish worship. Classes will focus on the voice as an instrument, music as a language of the soul, and the internal music of the liturgy. This class is a wonderful follow-up to Jewish Practice and Belief, but JP&B is not a prerequisite for this course and no Hebrew is required.

Instructor: David Harris

Schedule: 4 weeks, January–February 2004

Fees: to be announced in September *Kol Tikvah*

Hebrew Study

Hebrew—Year One
(Beginning, Hebrew I, Hebrew II)

This yearlong Hebrew course provides a foundation both for participants wishing to understand prayers and for those preparing for Bar/Bat Mitzvah. Study begins with Hebrew reading and writing, continues with basic grammar and vocabulary, and progresses to reading comprehension. The course is designed to prepare learners to read and understand the prayer book in Hebrew. An examination of the most important Shabbat and Holy day prayers and some study of Biblical grammar form part of this first year of study. This class (or the equivalent level of competency in Hebrew) is required for congregants preparing for a Bar/Bat Mitzvah.

Instructor: Elaine Frankowski
Schedule: 28 weeks, September – May, 2003/04
Fees: to be announced in September *Kol Tikvah*

Jewish Culture Potpourri

Back this year by popular demand!! Five one-of-a-kind, enlivening and enlightening programs on topics of cultural interest. Plans for this year include sessions on Jewish Philately, synagogue architecture, local Jewish response to events-of-the-day, contemporary Jewish writing, the Judaica collection at the MIA, and more.

Rhoda Lewin launches the Fall 2003 series with a talk on the history of Reform Judaism in Minneapolis. Rhoda is the author of *Jewish Community of North Minneapolis* (Arcadia Publishing, 2001). **She will speak at 10 a.m. on Sunday, September 14. The location will be announced in the September *Kol Tikvah*.**

Guest Speakers: to be announced in September *Kol Tikvah*
Schedule: 5 Sundays, September – December, 2003
Fees: None

Adult Education is also an extremely important part of Shir Tikvah's contact with its members, and has contributed to the congregation's continuing growth. In addition to the Sunday morning "Jewish Culture Potpourri" and a Spring Seminar with Rabbi Offner, the curriculum includes weekly Hebrew classes and other on-going classes taught by Rabbi Offner, Shir Tikvah members and guest lecturers. (Courtesy of Shir Tikvah.)

דִּבְרֵי תִקְוָה

WORDS OF HOPE

Collected sermons, 1988-2000

In celebration of the B'nai Mitzvah of

Congregation Shir Tikvah

May 12, 2001

In 2001 Shir Tikvah published *Words of Hope* in celebration of the congregation's B'nai Mitzvah. Edited by Ellen Kennedy and designed by Susan Moro with assistance from Julia Hatler, the book begins with an Introduction by University of Minnesota Prof. Billie Wahlstrom, who joined Shir Tikvah in 1989 and served as President from 1999 to 2001. It includes Rosh Hashonah sermons by Rabbi Offner and congregants Jeff Edelson, Bert Black, Rhona Leibel, Carolyn Levy, Linda Crawford, Jeff Zuckerman, Ellen Kennedy, Lucy Kanson, Sam Kaplan, Bob Schlesinger, Ed Magidson, Phyllis Kahn, and Howard Ornstein. (Photo by Tom Lewin.)

Five

OUR EVERYDAY LIVES
WORK, PLAY, SCHOOL, SPORTS, AND SO MUCH MORE

As the years passed, members of the Jewish community became more involved in the general community. They developed very successful businesses, and were elected to public office, despite the fact that in 1947, in an article published in a national magazine called *Common Ground*, author Carey McWilliams had described Minneapolis as "the anti-Semitism capital of the United States."

They also began to move to new homes in the suburbs after World War II, including Edina, whose first developer had refused to sell homes to Jews. Many of them chose to stay in the city, however, buying homes on or near Lake of the Isles, Cedar Lake, and Lake Calhoun.

A growing number of families have sent their children to private schools like Breck and Blake, and more recently the Minneapolis Jewish Day School, but most of their children attended public schools. These included Kenwood, Blaine, and Sumner Elementary Schools, Jefferson Junior High, West High School, and Southwest High School after West High was torn down in 1982. Many of their children were involved in sports, school band and choir, and other activities, and spent the summers camping, or working as camp counselors.

Many Jewish immigrants to Minneapolis also created new businesses, including major corporations like Medtronic, Best Buy, and Plywood Minnesota, a building supply firm founded by Rudy Boschwitz, who left his sons in charge of his business in 1978 when he became the first Jew in Minnesota history to be elected to the United States Senate.

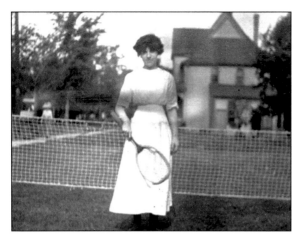

Tess Osterman was a woman ahead of her times. A 1916 graduate of the University of Minnesota, she also studied at Columbia University, taught in the Minneapolis Public Schools, and taught Sunday School and Confirmation classes at Temple Israel. (Courtesy of Jean Minter.)

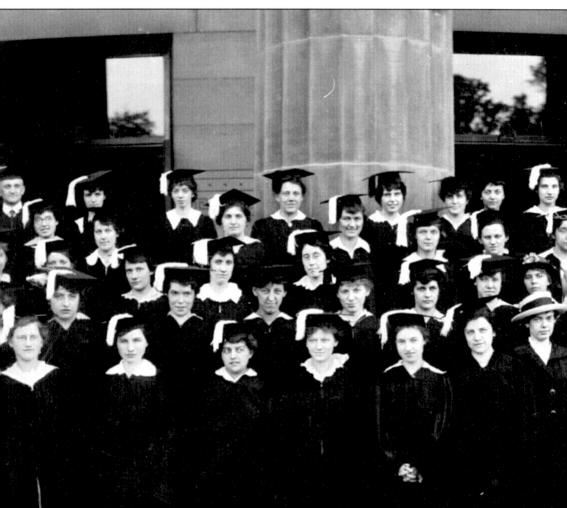

This 1916 College of Education graduation ceremony at Northrop Auditorium on the University of Minnesota campus included Shaarai Tov members Tess Osterman and

Tess Osterman and her friend Tecla Ziskin played golf on Sundays during the summer. (Courtesy of Jean Minter.)

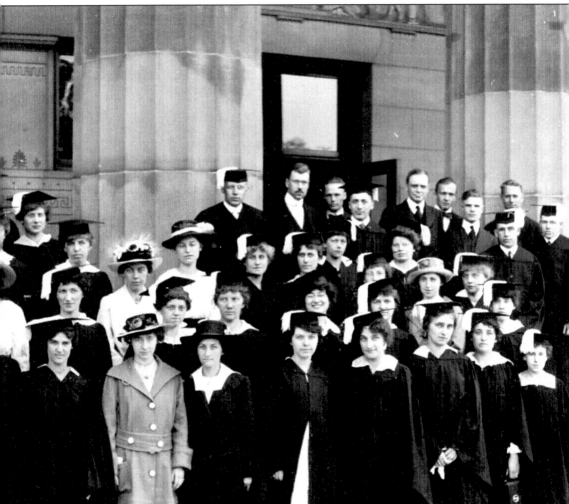

Tecla Ziskin. (Courtesy of Jean Minter.)

❈PROGRAM.❈
PURIM ✦ ENTERTAINMENT.
R. C. SABBATH SCHOOL,
March 24th.

DRAMA OF
QUEEN ❈ ESTHER!
LAST ACT.

KING	HENRY DEUTSCH
QUEEN	BECKY MICHAELELS
HAMAN	JONAS WEIL
MESSENGER	SOL. SINSHEIMER

OPERETTA---FOUR AND TWENTY BLACKBIRDS.

KING	MICHAEL SOLOMON
QUEEN	MAY GLUCK
MAID	MINNIE SCHACK
MASTER COOK	MOSES BLUMENKRANZ

——COOKS.——

George Wilk.	Willie Grnenberg.
Louis Benson.	Eddie Newman.

——BLACKBIRDS.——

Helen Schack.	Sig. Abrahams.
Maud Rees.	Arthur Abrahams,
Sylvie Frank.	Roland Abrahams.
Bella Stern.	Howard Keyser.
Leah Berman.	Morrie Michaels.
Mattie Schilt.	Louie Davidson.
Emil Robitscheck.	Bennie Gitlelson.

Music and entertainment have traditionally been part of congregational outreach to encourage community involvement. Hundreds of members of the Jewish community flocked to musicals like this *Drama of Queen Esther* with excerpts from the operetta *Four and Twenty Blackbirds.* (Courtesy of Temple Israel.)

The
Jewish Normal School

Under the Auspices of

Temple Israel
Minneapolis

Mount Zion Temple
Saint Paul

Presents its first Intensive Course of Lectures for the year 1927-1928 on Monday, Tuesday and Wednesday evenings, January 23rd, 24th and 25th.

DR. JACOB SINGER, of Chicago

Will present the following Lectures:

I. MONDAY EVENING, JANUARY 23RD, 8:15 at MT. ZION TEMPLE, St. Paul.
 (Holly Avenue and Avon Street)

"An Illustrated Lecture on Jewish Music"

II. TUESDAY EVENING, JANUARY 24TH, 8:15 at TEMPLE ISRAEL, Minneapolis.
 (10th Street and 5th Avenue So.)

"The Music and Poetry of the Bible"

III. WEDNESDAY EVENING, JANUARY 25TH, 8:15 at MT. ZION TEMPLE, St. Paul.

'The Music and Poetry of the Prayer Book'

Questions and discussion will follow the lectures. All students of the Normal School are expected to attend the entire course.

THE PUBLIC IS CORDIALLY INVITED

Scholarly presentations by visiting lecturers were also very well-attended. In January, 1928, visiting Chicago professor Jacob Singer lectured at the Jewish Normal School, a joint project sponsored by Temple Israel and St. Paul's Mount Zion Temple. (Courtesy of Temple Israel.)

Jacob Ellis was a talented musician who wrote popular music. When Fox Publishing in New York City hired him as a traveling salesman to sell their sheet music in the Midwest, he also sold his own books of songs. (Courtesy of Jean Minter.)

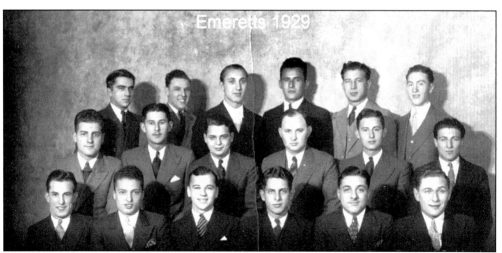

Members of this young men's social club called themselves the Emeretts because most of them lived on or near Emerson Avenue. Pictured from left to right are: (front row) Max Dudick, Morris and Sam Liss, Max Lubet, Lou Dicker, and Sol Lipkin; (middle row) Maurice Gordon, Sidney Roberts, Sawyer Eisenstadt, Lou Hoffman, Sol Fisher, and Max Karatz; (back row) Harold Rappaport, Al Lipkin, Herb Schwartz, Si Weisman, Harry Fine, and Bernard Goldstein. (Courtesy of Rachel Lipkin.)

Until they were replaced by city buses in the late 1940s, streetcars were the only means of transportation for many Twin Cities residents. The streetcars, and the buses that replaced them, ran 24 hours a day downtown and in every neighborhood, including this intersection at Twenty-Fourth and Lyndale South. (Photo by Tom Lewin.)

Automobiles began to proliferate after World War II ended, with increasing traffic in residential areas like this intersection at Grant Street and Spruce Place, looking west toward Loring Park in 1949. (Photo by Tom Lewin.)

NORTHERN STATES POWER COMPANY
15 South Fifth Street
MINNEAPOLIS, MINN.

ELECTRIC BILL

TELEPHONE
Main - 6251

OFFICE HOURS
8:00 a. m. to 5:00 p. m.

GROSS BILL DUE AFTER JUL 18 1942

RONNEY L HARLOW

BILLING SYMBOLS

1512 SPRUCE PLACE 305 3FL. 1804
47141

ES —ESTIMATED BILL (See Other Side)
TR—FINAL BILL, PREVIOUS ADDRESS
MC—METER CHANGE
TOT—TOTAL AMOUNT DUE

| METER READINGS | | KW. HOURS USED | DEMAND | READING DATES | SERVICE | GROSS BILL | NET BILL |
PRESENT	PREVIOUS						
6 9 2 2	6 8 8 2	4 0		JUN 29 MAY 29	DOMESTIC	1.85	1.76

REDDY KILOWATT,
Your Electrical Servant, Says . . .

"I suggest that just for fun
Divide this bill by the jobs I've done,
So many things by day and night,
Each one at the cost of only a mite."

Buy More U.S. War Savings Bonds and S

Paychecks were a lot smaller during World War II, but the cost of living was a lot less, too. Ronney Harlow's electric bill for the month of June, 1942, was only $1.85, and if he paid his bill before July 18, he'd save 9 cents! (Courtesy of Tom Lewin.)

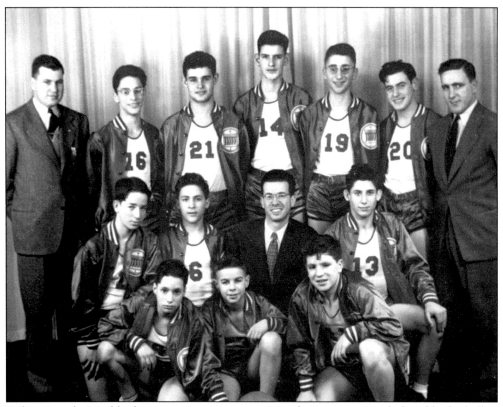

Before Temple Israel had a gymnasium, teenagers joined sports teams and played basketball at the neighborhood YMCA on Hennepin Avenue. (Courtesy of Temple Israel.)

Minneapolis's first World War II casualty was 23-year-old Naval Ensign Ira Weil Jeffrey, who was killed in the December 7, 1941, Japanese attack on Pearl Harbor. Jeffrey, who had been president of Temple Israel's junior congregation, was honored on December 12 at a special service that Temple had originally planned as a celebration of the sesquicentennial of the adoption of America's Bill of Rights. (Courtesy of *Minneapolis Star Journal*.)

Ira Jeffery Is City's First War Casualty

Ensign Killed in Action at Pearl Harbor

War struck directly at a Minneapolis home today, leaving the parents stunned and almost unable to believe that their only child had been the first reported war casualty from Minneapolis.

The parents are Mr. and Mrs. David C. Jeffery, 1312 Douglas avenue, and the telegram from the navy department which they received last night told them their son, Ensign Ira Weil Jeffery, 23, was "killed in action" Sunday in the Japanese attack on Pearl Harbor.

Crushed by the news, the Jefferys were barely able to talk about it today.

"We had already sent holiday packages," Mr. Jeffery said. "We got our last letter from Ira a week ago. There was no feeling of alarm in it, no indication that anyone had fear of an early attack.

IRA JEFFERY
First Minneapolis war casualty

"Ira, who had enlisted, was home shortly after graduating from the Northwestern university training station last June. He was assigned to Honolulu in July, but had been hoping and planning to get home next spring."

* * *

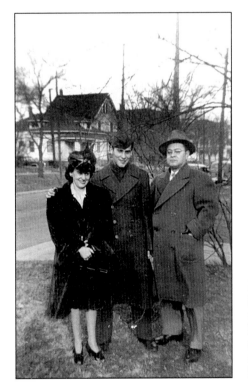

Howard Jay Schwartz, shown here with his parents, Estelle and Benjamin Schwartz, missed his high school graduation, which would have been on his 18th birthday, because he dropped out of school in 1944 to enlist in the U.S. Army. He was fighting in Germany when World War II ended on May 6, 1945. (Courtesy of Anita Schwartz.).

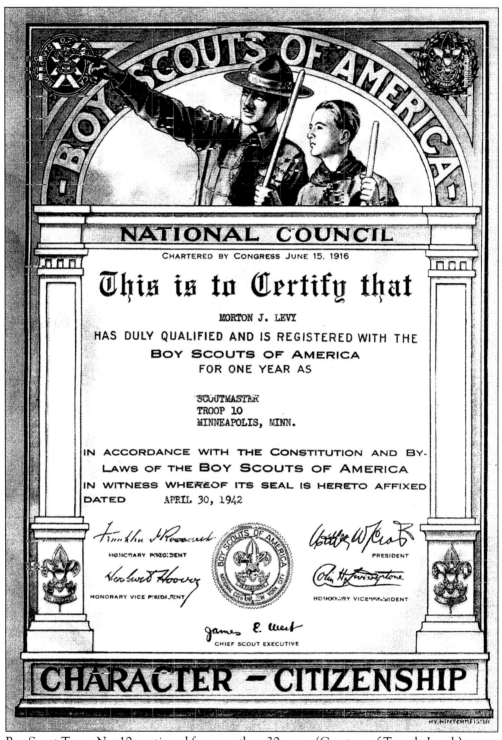

NATIONAL COUNCIL

CHARTERED BY CONGRESS JUNE 15, 1916

This is to Certify that

MORTON J. LEVY

HAS DULY QUALIFIED AND IS REGISTERED WITH THE

BOY SCOUTS OF AMERICA

FOR ONE YEAR AS

SCOUTMASTER
TROOP 10
MINNEAPOLIS, MINN.

IN ACCORDANCE WITH THE CONSTITUTION AND BY-LAWS OF THE BOY SCOUTS OF AMERICA

IN WITNESS WHEREOF ITS SEAL IS HERETO AFFIXED

DATED APRIL 30, 1942

HONORARY PRESIDENT

PRESIDENT

HONORARY VICE PRESIDENT

HONORARY VICE PRESIDENT

CHIEF SCOUT EXECUTIVE

CHARACTER – CITIZENSHIP

Boy Scout Troop No. 10 continued for more than 30 years. (Courtesy of Temple Israel.)

Photos of campers learning how to put up their tents and doing other chores : for Temple Israel congregants being a Boy Scout in the healthy outdoors was fun, but it was also a learning experience. (Courtesy of Temple Israel.)

The annual Boy Scout Sabbath worship service at Temple Israel also encouraged parents to enroll their sons in the Boy Scouts.

Sleeping in tents was an adventure for many young Scouts, but not for their Troop leaders, who were experienced campers. (Courtesy of Temple Israel.)

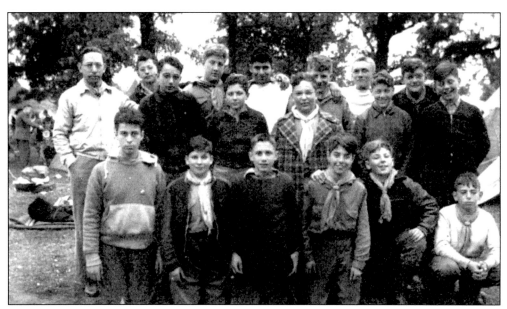

On the last day of camp, Temple Boy Scouts posed with their counselors for a farewell photo. (Courtesy of Temple Israel.)

In 1945, Temple Israel had started a day camp, with classes at Temple and swimming at Lake Nokomis. Then, in 1965, Men's Club, with Gerald Friedell as president, bought 18 acres of rolling hills, shaded woods and lakeshore at Lake Minnetonka and built Camp Teko, which is now used for weekend retreats and Religious School and Confirmation Class outings. (Courtesy of Temple Israel.)

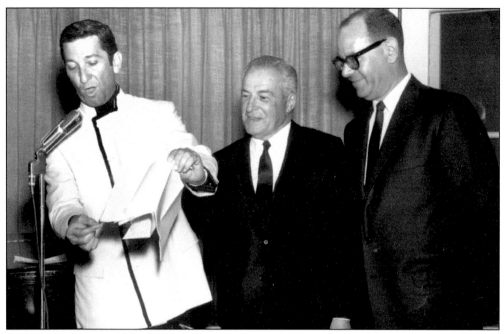

By 1968 Temple Israel had finished paying its mortgage on Camp Teko. Members of Men's Club who took part in the celebratory mortgage-burning ceremony were, from left to right, President Chester Grossman, Sam Shapiro, and Larry Greenberg. (Courtesy of Temple Israel.)

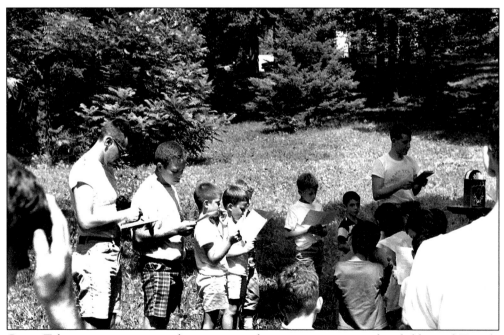

Camp Teko continues to provide a very popular camping program for children of Temple members and the general community. In addition to supervising swimming, canoeing, and other outdoor sports and athletics, counselors also conduct Friday night worship services. (Photo by Robert Rosenberg, courtesy of Temple Israel.)

During the 1970s some Temple youngsters also went to day camp at Camp Kichiyapi. (Photo by Tom Lewin.)

Life jackets have always been a requirement when children at Kichiyapi and Camp Teko go canoeing. (Photo by Tom Lewin.)

When winter comes, many children turn to ice-skating. At Parade Ice Arena the Minneapolis Park Board sponsored many classes, programs and special events like this 1989 Ice Show. The "Shooting Stars" performers, shown with instructor Michael Luedtke, included Yvonne Cherne, Maureen Jordan, Jessie Levin, Sinikka Sinks, Annie Weissman, and Adie Wilbrecht. (Courtesy of Minneapolis Park Board.)

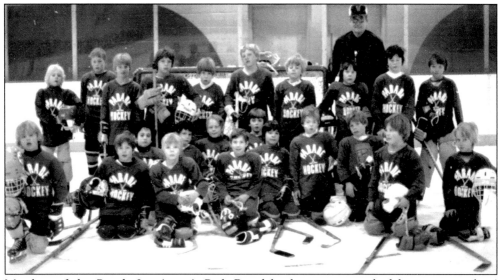

Members of the Parade Ice Arena's Park Board hockey team, coached by team members' fathers during one-hour sessions on Tuesday and Thursday evenings and Saturday mornings, also practiced and competed at Kenwood Park's outdoor skating rink and on Lake of the Isles. (Photo by Tom Lewin.)

Eighth Grade Graduating Exercises

CENTRAL HIGH SCHOOL DISTRICT

Thursday, June 9, 1904, at 3:30 P. M.

WESLEY CHURCH.

We gather the grain, if we sow the seed.

—Lucy Larcom.

✍ PROGRAM ✍

ORCHESTRA. Petite Symphonie. *Moret*
DOUGLAS SCHOOL

RECITATION. The Story of Some Bells.
John Skanse *Washington School*

VOCAL SOLO. Nocturne *Denza*
Alma Larson *Madison School*

RECITATION. The Legend Beautiful. *Longfellow*
Lynne Major *Lyndale School*

VIOLIN SOLO. Ninth Concerto. *Chas. de Briot*
Francis Pauly *Clinton School*

RECITATION. The Russian Christmas. . . *Emma Denning Bank*
Irma Beehler *Whittier School*

CHORUS. Fairies Lullaby *Thomas*
MADISON SCHOOL

RECITATION. Sandolphin. *Longfellow*
Helen Day *Emerson School*

VOCAL SOLO. The Great White Throne.
Clyde Winkleblec *Garfield School*

RECITATION. From a Far Country *Roberts*
Grace W. Ganssle *Bryant School*

"Battle Hymn of the Republic." . . . **The Classes**

Neighborhood public schools attended by children of Shaarai Tov members included Douglas, Lyndale, and Emerson elementary schools and West high school. In 1904 the south Minneapolis schools held a community graduation ceremony at Wesley Church. (Courtesy of Jean Minter.)

KENWOOD TIMES

1908 – 1980

Elementary schools also published student newspapers. This 1988–89 issue of the Kenwood School *Times* featured a cover photo of their original school building. Kenwood now has a new modern building, but many neighborhood parents send their children to private schools like Breck, Blake, or Minneapolis Jewish Day School. (Courtesy of Tom Lewin.)

Jefferson Junior High School's Annual Spring Concert and Fashion Review featured selections from "Fiddler on the Roof" and George M. Cohan's "You're A Grand Old Flag" performed by a student band that included Lynn Ackerberg, Carla and Sandra Waldof, Ellen and Susan Lewin, Larry Chesler, Lisa Fogelman, Charles Selcer, Ellie Siegel, Andy Kantar, Deborah Brin, David Abrahamson, Tom Cherwien, Tom LaBelle, Andy Schoenbaum, Daniel Lekovich, Ronnie Harris, Greg Meyers, Ann Bach, Laura Gross, Marian Parker, and Sandra Rovick. (Courtesy of Tom Lewin.)

This Spring 1970 issue of West High School's *Arthur* literary magazine was edited by Deborah Brin and Susan Lewin, with faculty members Karen Fischer and Betty-Sue Lipschultz as advisors. (Courtesy of Tom Lewin.)

THE TIMES
Anwatin School
"all the heavy news"

Vol.1, no.4 June 6, 1979

Spirit Week May 21-25

By Jeffrey Lewin and Laura Sanocki

Spirit Week was a fun ending for the school year. Spirit Week consisted of 5 special days the week of May 21 to 25.

Monday was Dress-up Day. Many students wore fancy duds.

Tuesday was Hat Day. Kids wore baseball hats and satin hats. There was one top hat and a chef's hat.

Wednesday was Blue and White Day. They are the school's colors.

Thursday was 50's Day. It was the greatest. The girl's wore bright lipstick and kissed the boys.

Friday was Activities Day. There were many track and field events.

* * * *

By Jeff Lewin

Activities Day at Anwatin was on May 25 This was the last day of Spirit Week.

There were a variety of events. There was a relay, marathon, discus throw, shotput, broad jump, high jump, hurdles, a 50 yard dash.

The shotput, broad jump and high jump took place in the gym. The rest of the activities took place outside. It was a hot day with few clouds in the sky. Everyone had lots of fun.

Foreign Language Week A Success

By Hilary Robertson and Paige Rogers

National Foreign Language Week, April 1 to 7, did not go unnoticed at Anwatin. Almost 350 students participated in the activities. All spoke a little (or a lot) of either French, Spanish or German.

Some activities were: locker decorating with judging and prizes, wearing paper buttins with sayings on them in the language you take, and another thing which the teachers "sponsored" was students teaching an uninformed student a sentence in their language. If you did this successfully, your teacher would give you both a "treat."

The big event of the week was the Continental Breakfast. For 50¢ you were given a hard roll (with your choice of butter, jam or both), a small glass of apple juice and hot chocolate.

National Foreign Language Week was fun, rewarding and a success for staff and students.

Photo by Ericka Wilcox.

Sculpture Finished!

The new clay sculpture is finally finished and in place in the courtyard.

Students designed sections of the disks. The artist-in-residence for the sculpture project was Craig Campbell.

Students at Anwatin Middle School also published a weekly newspaper called *The Times*. (Courtesy of Jeff Lewin.)

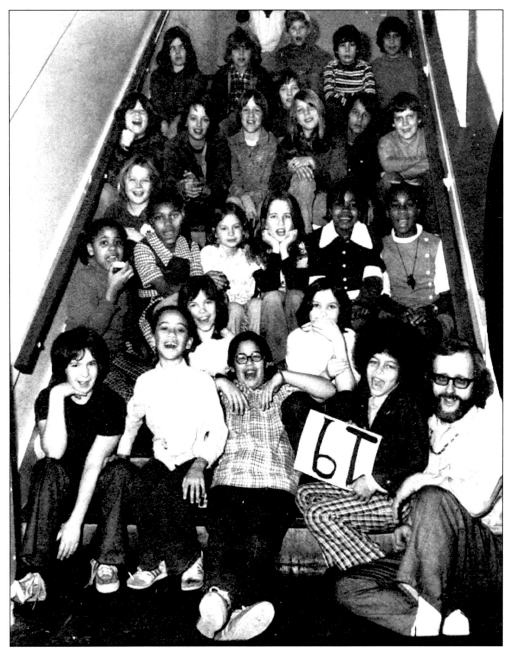

Harrison Open School students in Room 19, including Michelle Levine, Pam and Betsy Goldfarb, Kate Lewin, and Jenny Roth, posed for their annual photo with one of their favorite teachers, Jim Selby, in 1976. Penny Jacobs was also a very popular teacher at Harrison Open School for many years. (Courtesy of Kate Shamblott.)

HESPERIAN, 1933 —

A concrete idea of an athletic field manifested itself as early as 1920. In that year, part of the "mud pond" back of the school was purchased. Other plots were added in 1925, 1926, and 1929. The Board of Education gave West permission in 1929 to grade and condition the field for athletics. The entire project cost about $18,000.

In 1932 West joined the National Honor Society.

(During World War I) students and alumni who enlisted totalled 760, 24 of whom remained "over there". Those who remained at home conducted numberous drives to raise large amounts of money for a Red Cross rest hospital and for the purchase of an ambulance for relief work in France. Students also collected 11,000 books for American soldiers and assisted in supporting French or Belgian orphans and maintaining war gardens.

West High TIMES, March 26, 1941 —

Swimmers Secure City Title for 14th Year in Row

TIMES, May 21, 1941 —

West on Top in Baseball as Team Beats South, 6-5

"Head high — chin in — shoulders back."

This was the common reminder to all West students observing Posture Week, April 28 to May 2. Girls competed in a school-wide contest to be selected for best posture. Audrey Kaplan won first place . . . in the final judging.

HESPERIAN, 1943 —

Johnny and Jane Cowboy have tossed away their play clothes and put on their victory duds. Gone are the carefree days spent roaming leisurely through the halls of West. Instead — rigid physical training —learning to identify aircraft — victory lunches — training for defense. Whether it is merely studying a brainy aviation math problem, working for Red Cross, or buying U.S. saving stamps, West's students are doing their bit for Uncle Sam.

HESPERIAN, 1945 —

Again the HESPERIAN is dedicated to the 2,150 students of WEST who have entered the armed forces of their country and most particularly to those eighty-two who will never return.

For their help in securing what we hope will be an imperishable victory, WEST students will always revere their names and be inspired by their sacrifices.

This brief history of West High School 1920–1945 included Audrey Kaplan as prizewinner in a 1941 competition that no longer exists—a school-wide Contest for Best Posture! (Courtesy of Tom Lewin.)

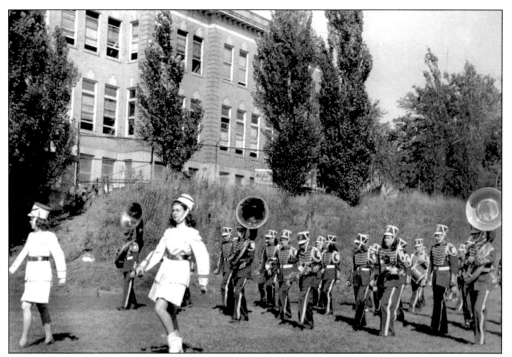

Members of West High School's marching band practiced in the open area near West High School. (Courtesy of Tom Lewin.)

The band performed at the school's basketball, football, and baseball games and also marched in the annual Minneapolis Aquatennial parades. (Courtesy of Tom Lewin.)

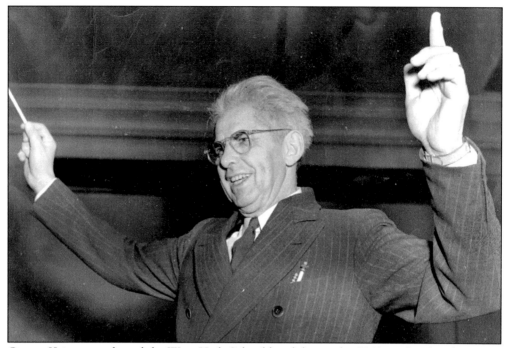

George Krieger conducted the West High School band during the 1940s and 1950s. (Courtesy of Tom Lewin.)

1970 commencement

West High School

In the 1960s West High students competed with designs for the cover of their Commencement Program. (Courtesy of Tom Lewin.)

When school superintendent Richard Green closed one-fourth of Minneapolis's public schools in 1982, West High School was demolished and the land was sold to a contractor who built a seniors' apartment building. West High's last Commencement Program included presentations by valedictorian Carol Rees, Dan Rotenberg, and Kate Lewin, an alumnus of the Twin Cities' Talented Youth Mathematics Project. (Courtesy of Kate Shamblott.)

PROCESSIONAL
"Pomp and Circumstance"
Brass Emsemble MR. WILLIAM SCRIPPS, *conducting*

Trumpets	Tuba
CHARLES LAUGHLIN	GORDON CRAIG SCHUTTE
STEVEN ROTTMAN	
JASON PINKNEY	Percussion
	ANDREW JOHNSON
French Horns	PAUL PAGUYO
MS. PAMELA CHAPIN	ROBERT SCOTT
MR. NEIL DELAND	
MR. DONALD FEENEY	Organist
	MR. GIL KIEKENAPP
Trombones	
MR. DENNIS DYCE	
ELIZABETH KELLAM	
MR. STUART STEVENS	

INVOCATION MR. JAMES BAXTER

OUR NATIONAL ANTHEM.................. MRS. CAROLE THOMPSON
accompanied by.......................... Brass Ensemble

THE CLASS OF 1982 SPEAKS CAROL REES
Valedictorian

PRESENTATION OF TOP STUDENTS OF 1982.....................
MR. ROBERT LYNCH
Principal

JONI L. BIESEMEIER	ELIZABETH A. RINKER
CHARLES A. LAUGHLIN	DANIEL D. ROTENBERG
KATE E. LEWIN	CAROLYN E. SALMON
SHEILA L. PETERSON	DAVID T. SINNOTT
CAROL A. REES	MARTHA B. STOKES
	LAURI A. VIEBAHN

West's Diamond Jubilee
1907-1982 and the Last

PRESENTATION OF GUESTS

PRESENTATION OF THE CLASS LEONIDAS CHECHERIS
Class President

NATIONAL HONOR SOCIETY PRESIDENT
..JOHN SHULMAN

STUDENT COUNCIL PRESIDENT..............STACIE FOEHRINGER

RECOGNITION OF CLASS..........................MRS. JOY M. DAVIS
Director, Board of Education

MEMORIES..EYVETTE HARRIS
Ebony and Ivory

AWARDING OF DIPLOMAS...............MRS. WILLARENE BEASLEY
Assistant Principal
MR. ARTHUR INDELICATO
Assistant Principal

READERS... MISS ELEANOR MATSIS
MR. JAMES MCDONELL

OH GOD, OUR HELP IN AGES PAST REBECCA DAY

RECESSIONAL.. Brass Ensemble

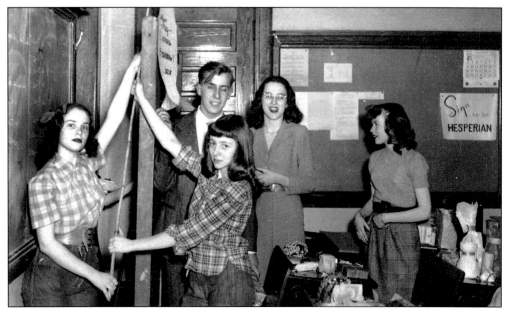

In the 1940s West High School students displayed a flag urging seniors to help put together their yearbook, the *Hesperian*. (Courtesy of Tom Lewin.)

Although most Twin Cities high school graduates lived at home and attended the University of Minnesota as "commuter students" during the 1940s and 1950s, many joined fraternities. This costume party at Zeta Beta Tau was an annual event, and 1949 attendees included Tom Feinberg, Bill Sabes, Julius Klein, Bob Stone, Howard Weiner, Ron Mankoff, Jerry Kahn, Gene Geller, Shel Rein, Harvey Goldstein, Tom Lewin, and many fellow ZBT members and their girl-friends. (Courtesy of Tom Lewin.)

Women in the Minneapolis Jewish community have always taken an active role in fundraising for Israel, as well as for their synagogues and other community programs. Mrs. Erwin Pentel and Mrs. David Kaplan were both actively involved in Hadassah's April 1962 style show and luncheon. (Merle Morris, photographer, courtesy of *American Jewish World*.)

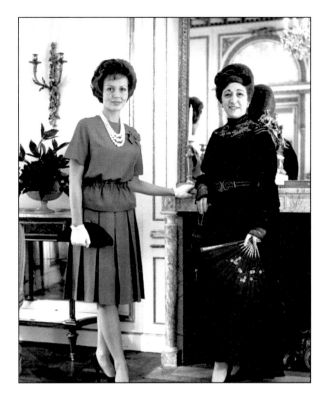

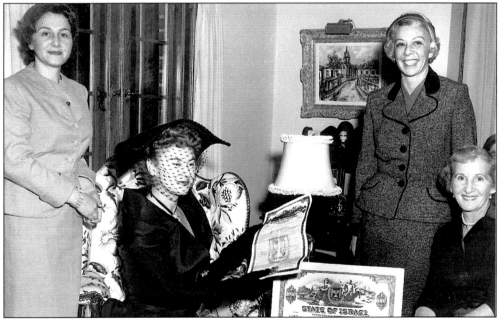

On a nationwide trip to sell Israel bonds in September 1951, internationally known entertainer Hildegarde came to Minneapolis for a luncheon at the home of Mrs. Samuel Maslon, where guests bought $10,600 in Israel bonds. Pictured from left to right are Mrs. Leo Gross, Hildegarde, Mrs. Ben Berger, and Mrs. Maslon. (Photo by Ostrin-Steinberg Studios, courtesy of *American Jewish World*.)

Minnesota Jewish Life, a popular monthly magazine published by Rosalie Kiperstin in the late 1980s and early 1990s, sponsored a Chicken Soup Cook-Off at Hotel Sofitel coordinated by food editor Connie Savitt Sandler. First-prize winner Phil Steinberg credited his wife for introducing him to the kitchen as "relaxation therapy," and said it's OK to stop worrying about cholesterol because "my mother's secret ingredient in her chicken soup was love, not fat." (Courtesy of *Minnesota Jewish Life*.)

And then there are the Jewish entertainers. Some have other careers and work part-time doing what they love; others perform full-time. Members of Sim Shalom Klezmer Band, which takes the bandstand at many community and private celebrations, have included Adam Wexler, Larry Katz, Dave Haberman, Ivan Kalman, Mark Stillman, Shelley Hamm, and (not shown) Tom Stroben, Dale Mendenhall, and Ada Yashaya. (Courtesy of Georgia Kalman.)

Shalom Minneapolis, sponsored by the Minneapolis Federation for Jewish Service, has welcomed Jewish newcomers to the Twin Cities since the 1950s, with a three-month JCC membership and information on local Jewish organizations, schools, shops, houses of worship, etc. Penny Zeissman, who chaired the program for many years and supervised more than 80 volunteers, 3/4 of whom were relative newcomers, welcomed Dr. Glenn and Marcia Moradian and their family to Minneapolis when Dr. Moradian received a two-year fellowship in radiology at the University of Minnesota. (Courtesy of photographer Bette Globus-Goodman and *Minnesota Jewish Life*.)

Sandy Olkon and Bobbie Goldfarb, with associate Jean Bundt, founded the Jewish Dating Service in 1979. Rabbi Max Shapiro gave them office space at Temple Israel, and by 1988 they were taking credit for over 100 Jewish marriages. Marilyn Weisberg joined the staff when it became a business enterprise with offices in St. Louis Park, charging members $300 for a minimum of eight dates in six months, and $90 for a six-month extension. Enrollees range from age 19 to people in their 80s, and mothers and grandmothers frequently sign up their sons and grandsons. (Photo by Betty Globus-Goodman, courtesy of *Minnesota Jewish Life*.)

Bob Stein was an all-American football player at the University of Minnesota when he was hired by the Kansas City Chiefs, and he was only 21 years old when the Chiefs defeated the Minnesota Vikings in Super Bowl III. During his years in Kansas City he also attended Law School at the University of Missouri, and in 1976 he came home to Minneapolis to practice law full-time. He stayed connected with the sports world, though, and was president of Marv Wolfenson and Harvey Ratner's Minnesota Timberwolves in 1987, when they built their arena in downtown Minneapolis. (Courtesy of *American Jewish World*.)

Jennifer Kline was crowned Mrs. America in 1988 and represented the United States in the international Mrs. World pageant, where she was honored with the title of second runner-up. She prepared for the competition with assistance from Faith Schway, director-owner of Premiere School of Self-Improvement and Professional Modeling, who has trained more than 50 local, regional, and national winners. Kline has worked as a professional model and fashion reporter, appearing in ads for *Seventeen* and *Vogue* magazines, and in commercials for Dairy Queen, Kellogg's Raisin Bran, MacDonalds, and Target. She and her husband Rick, president of Kline Auto World, have two sons, Conner and Logan. (Courtesy of Jennifer Kline.)

Ken and Gerry Boschwitz took over their father's thriving business, Plywood Minnesota, when Rudy Boschwitz was elected to the U.S. Senate. Their mother, Ellen, commuted between Washington D.C. and Minneapolis, however, to continue as Plywood Minnesota's buyer for wallpaper, window treatments, and housewares. (Photo by Bette Globus-Goodman, courtesy of *Minnesota Jewish Life*.)

Mark Rosen played baseball and basketball at St. Louis Park High School. He majored in journalism at the University of Minnesota but never graduated because his part-time job as a WCCO sports reporter quickly turned into full-time, and by 1982 he was WCCO-TV's prime-time anchor and sports director. His "sports idol," he once said, was L.A. Dodgers pitcher Sandy Koufax, because Koufax refused to play in the World Series on Yom Kippur. (Photo by Betty Globus-Goodman, courtesy of *Minnesota Jewish Life*.)

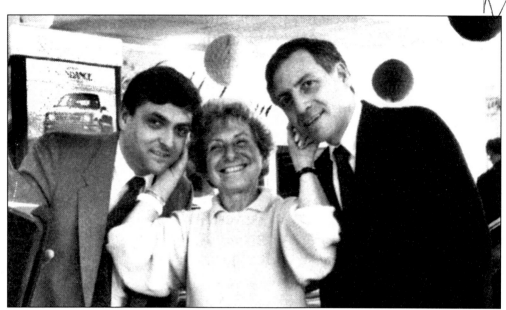

In 1990 Jim and Bruce Barnett and their mother, Ann, posed for a TV commercial advertising the "homey service and sincerity" they still provide today at their White Bear automobile sales agencies, Barnett Chrysler-Plymouth Jeep and Barnett Kia. The boys' father, Harold Barnett, started the business in 1956. (Photo by Bette Globus Goodman, courtesy of Bruce Barnett and *Minnesota Jewish Life*.)

Entrepreneur Gary Rappaport, owner of Northwestern Auto Parts Company (now known as NAPCO), and his wife Susan have always believed that sports are an important part of family life. They're adventurous skiers who winter in Aspen, and when they took their two college-age daughters, Debra and Lissie, on a vacation in the Canadian Rockies in 1989, they traveled by helicopter to mountain tops so they could ski down ungroomed slopes! (Courtesy of Susan Rappaport and *Minnesota Jewish Life*.)